the intimate agenda
inside the creative process

third eye press

published by
third eye press
box 548, aspen,
colorado, 81612
november 1996
ISBN 0-9644892-1-x

paramount printing
hong kong
typefaces: helvetica
 smack

photo credits:
morley clark by
lee fatherree
ann sperry by
brad miller
angela danadjieva by
frederick housel
cristina lazar by
andy regendantz

the intimate agenda

inside the creative process

editor barbara seidel

design cristin lazar

foreword arlene raven

agend**contents**

agenda**preface**

Within each of us smolders a scintilla or soul spark.

The intimate agenda accesses this mysterious dimension, presenting in word and image the processes, practices and products of seventeen creative individuals: visual artists, an architect, several writers and a musical composer. It explores the shape, texture and sound of creativity, identifying the expressive resources of a geographically diverse group.

The intimate agenda is intended as an inspirational book. Creativity lies at its core. Skim it. Read it. Explore fresh sources of ideas, new points of view. It is designed to inspire others to reconnect with their own process. Its intent is to share the hearts and minds of a selected group of contributors, and, in so doing, encourage others to open to possibilities and potentials within themselves. It is directed toward artists as well as non-artists who want to connect and express creatively. It encourages us all to look inward, to discover the mysteries and possibilities embedded in our personal unconscious.

This requires radical trust in the creative process but ultimately allows us to move beyond our current boundaries and uncover what no one other than oneself is capable of imagining. All the contributors live at this edge, where consciousness engages the unconscious, with no holding back, accepting the chaotic structure of a nonlinear mind, confronting ambiguity, complexity and contradiction within themselves and their work. This book honors creative expression as an experience integral to daily living.

What is creativity? It can be defined as the authentic external expression of inner energy patterns, no matter how strange or esoteric they might initially seem. The impulse to create arises deep within and moves outward in its own unique way, revealing an essential connection between all aspects of an individual's life. The ability to move freely between inner and outer as our creative centers are enlarged and redefined, comes with practice. We can learn to explore the creative edge, building momentum, so that when the unexpected occurs, it will be integrated into a new and original synthesis.

The word practice is used in the Eastern sense, revealing the complete person who is already there, rather than in the Western sense of practice as acquiring a skill. Practices refer to the repertoire of procedures that we each invent for ourselves; personal rituals that shape how we think and what we know. Art can become a form of individual practice when it is not done for an audience, but for the self.

The intimate agenda explores space: the inner landscape of the mind and the unconscious; the outer landscape of nature and the cosmos. Some artists source their work in the inner world. Jeremy Taylor's dreamwork, Morley Clark's abstract drawings, Linda Aroyan's meditative practices, and Rebecca DiDomenico's alchemical transformations are examples of interior processes made visible. They initiate their process within, then move outward, questioning, communicating and challenging us to understand the visible forms and images that emerge from darkness, from the mystery of the unknown.

Others discover a source for their creativity in the natural landscape. Nancy Head's African trip, Patrick Dougherty's vernacular structures, Allison Stewart's sacred spaces, Peter Stark's adventures with ice and snow, and Ann Sperry's space sculptures are examples. They begin with what is visible, and later move inward, still respecting and staying in touch with the intrinsic natural rhythms that evoked their artwork in the first place. They move from the real to the abstract, light to dark.

Individual artists cannot really answer the big question, but each has tried in his or her own way. As the book came together, five interrelated, often overlapping themes or sources for an intimate agenda emerged: **space, place, dreams, movement, and change**. Ultimately, these are the resources that merge to construct a multilayered **creative synthesis**. The foreword, by noted art historian and critic for the *Village Voice*, Arlene Raven, establishes a contextual framework.

If we empower ourselves with tools that develop alternative ways of being, we can all design our own intimate agenda, a plan for organizing life, a life that respects essence and our authentic inner core. If we learn to identify and create our own processes and practices, new forms and structures will begin to fluidly evolve; and then we can achieve a depth of awareness and creativity never before thought possible. I open this space with invitation and possibility....

barbara seidel

agenda **foreword**

footpath for the journey

*I, on my side, require of every
writer, first or last, a simple
and sincere account of his own
life and not merely what he
has heard of other men's lives;
some such account as he
would send to his kindred from
a distant land; for if he has
lived sincerely, it must have
been in a distant land to me.*

**Henry David Thoreau
Walden**

**My first glimmer of the intimate agenda
took place in the intimate space,
that first room of my own,
located in a newly discovered chamber
of my mind
that opened as speech began.**

In this place
hidden from the harsh and heartless
interventions of adults,
I could become
a first-person subject
in a corporeal environment
by engaging with,
what I would later understand as,
an ontological and cosmological dialogue
with a larger potential self.

What took birth
as a child's safe house of personal identity
initiated a life long structure of human selfhood.
So considered
self-possesion, context and difference
are intrinsic to the internal.
Invented in the mind and in the air,
the myriad forms of expression
that make up meditative
cosmic dances of creation
have often uncovered a truth
beyond facts and opinions--
a gospel that obeys
the more exacting requirements
for authenticity and integrity
in art.

For me, as for **Peter Stark**,
this is the writing room
where metaphors live.
The journey that happens here,
Morley Clark believes,
is fueled by the practice
of the journal, which charts
inner landscapes along the way.

Space, the three dimensional arena
in which material objects are located
and events occur,
ordinarily refers to physical place.
But psychic space is also a site—
a symbolic setting for the spirit
and also for the common good in a better world.
Both futuristic and idealistic,
this Walden of inner being
can become, equally, present.
The actual arena in which **Ann Sperry**
engages form and space
is identical to **Allison Stewarts's** sacred space,
a solely spiritual sphere.

Place can be inscribed as any location.
Ordinary surroundings and careful placement alike
are never merely neutral atmosphere
or disengaged background.
Place impacts on
human health, intelligence, behavior, and
even our most elemental senses of self.
Where we live
deeply affects who we are and will become.
"I must listen, translate, communicate and channel
visceral impulses into the composition of music,"
explains **Augusta Thomas,**
"a process that allows me to grow and develop,
with each new piece of music
becoming a journey of self-discovery."

space
inner
&
outer
place

Where a painting comes from
is where I am, in me,
at that moment and without time

Carol Anthony
respecting silence

It was august 1987.
I was forty-eight years old
and coming to the realization
that life was not going
according to plan.

Linda Aroyan
redesigning a life

I am paring down to essentials,
getting rid of all that is unnecessary,
but without removing the poetry.

Barbara Seidel
paring down to essence

Some projects go unbuilt because
they challenge established values.
Accepting rejection is part of the process.

Angela Danadjieva
envisioning the future

Place is external environment
but also interchangeably,
internal and personal,
enmeshed in universal change
that is synchronistic and evolutionary
— in what **Emil Lukas** calls
a "fractal dimension".
As **Lewis Knauss** cautions
"in order to understand a place,
one has to put in the required time
to connect."

transformation
change

Change that can ignite
in a purposeful place,
is often found between the lines.
It is ideally transformation
on a paradigmatic level.

Patrick Dougherty finds this connection
through the repetitive action
of working with saplings,
a macrology that gives the artist
a sense of abandon, release, and freedom.
The patterns that will emerge
with this kind of hands-on,
incremental knowing
move the individual
and, with him and her,
the whole.
Because such designs
configure the practices,
relationships and organizations
in a society,
any single act can encompass
all structures and systems
in their scope.

movement
toward an
edge

The kindred circle.
Equalizing, neverending.
The campfire and meditation wheel.
The circumference
of myself, yourself, and the world.
The pull of the gravitational nucleus
in certain paintings.
The place in which
Lynn Heitler sees
"what cannot be seen".

Traditional social constructions
including those within the arts
have not always allowed for
authentic support for artists.
At their best, they have enhanced a few.

Yet no creative individual
can fully occupy
his or her three dimensions
without an affirmative polity
of people and conceptual frames.
The intimate agenda
is this kind of contextualizing frame
and can inspire
those now sorely separate.
If artists and all people,
with an intimate agenda
probe the deeps of the inside,
they equally explore
the global breadth
of their own implications
and the reach of their work.

**The path to an unknown
and unexpected place
always invokes a choice.**

First, **Rebecca Didomenico's
cracking open the shell:**
This opening step,
may propel people
toward the margin or the center,
but does not necessarily pit individuals
against the whole.
Us and them are,
most fundamentally,
inseparable.

Within such a sympathetic surround
lies a safe and fertile state of mind and heart.
Psychological and metaphysical
as well as political and physical,
the spot closest to home and the bone
lies within the skin.

The art
of the intimate agenda
is a house
and the family that dwells within.
My musing is metaphorical
in which case
it is wise
to choose the inclusive metaphor.
Individuals
are molded by their homes;
fulfilled in the largest sense
in and through their communities.
Bodies of art
are produced through these unions
through individuals
and not by artists alone.
Jeremy Taylor reminds us that
we all share an unconscious
understanding of the universal
language of metaphor and
symbol in our dreams.

Purposeful gatherings
such as this volume can become
the physical, cultural, moral and social ecologies
that sustain a new vision of art.
Art thus conceived, in turn,
provides a reflective language
of forms, words and gestures
instrumental in making social and spiritual ideals
a reality.

metaphor & symbol
dreams

When I picture
the potential for my life and our lives
to set forth
in the empowering and ennobling directions
suggested by the dream
of a personal, particular, deeply shared union,
the image exceeds
my most cherished imaginings.
We approach **Nancy Head's** hope
to retrieve the lost soul
and **Michael Emmon's** wish
to speak of love.

**Everyone here speaks in turn in a singular voice.
But we are not, even one of us, alone.**

Arlene Raven, New York City, January, 1996

Physical space is a three dimensional arena in which objects are located and events occur, while psychic space is the symbolic setting for spirit. Artists create a dialogue between these inner and outer spaces.

As I come to understand a site, interesting things happen. My saplings intertwine with the surrounding space, creating spaces of transition between man and the natural world.
patrick dougherty

As the galaxies reveal their true nature and outer space becomes a part of our world, we learn to extend ourselves, eliminating the boundaries between inner and outer space.
ann sperry

space physical & psychic

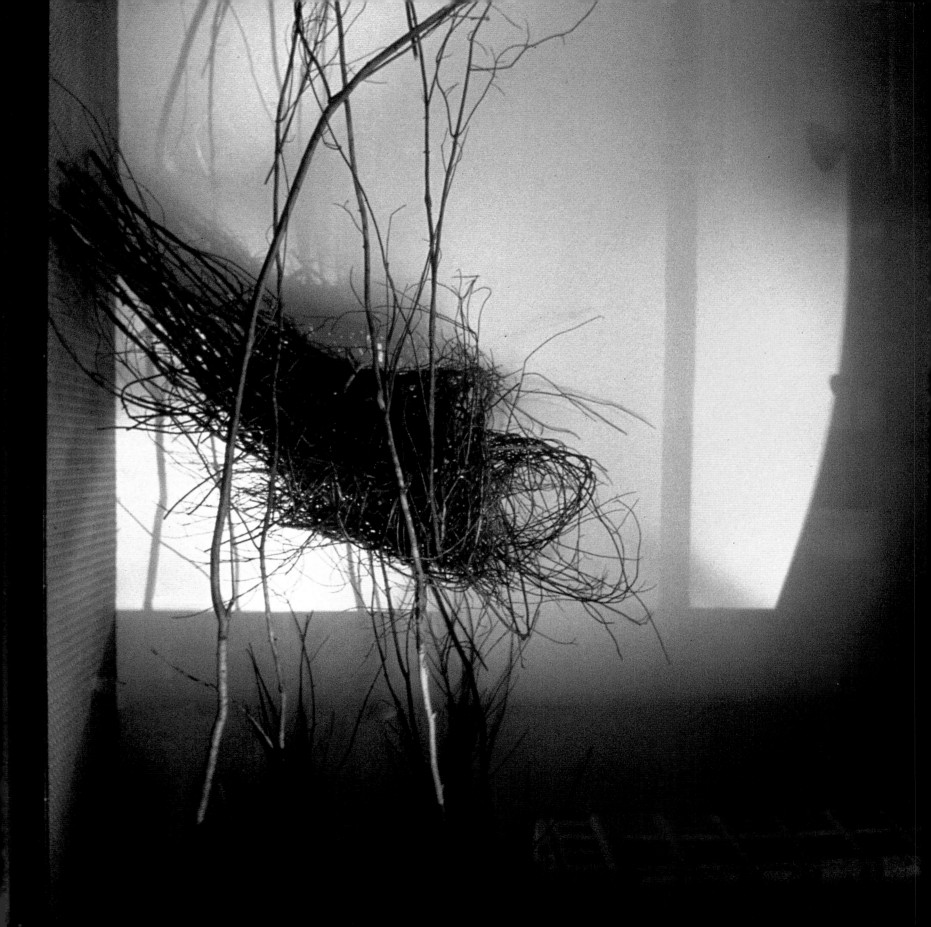

patrick dougherty

fusing man & nature

Patrick Dougherty grew up among the pine, dogwood, maple, magnolia, oak, and scrub brush of North Carolina. Out the doors and windows of his house were woods and more woods. Above the woods, the moon rose, and the smell of spring weather signalled that the woods were secretly growing and building

from a poem by Kate Farrell

There is a natural relationship between my sculptures and dance. Both are about gesture, motion and the movement of line and force through space. This actual construction process is not a sedate studio activity; but like dance, it is one that uses large motions and the entire body. The physicality of the process of making is evident in the final sculptures. Improvisation and constant reaction are the core of my process, as is a celebration of the ephemeral.

I construct large temporary structures that are built on site from tree saplings gathered in the nearby landscape. My primary compulsion is a feverish desire to handle saplings and enjoy their weight, color and potential to bend. No hardware is used in these constructions; there are only the saplings and my inclination to create. It may be the comfort of the repetitive act that gives me so much freedom and sense of abandon.

I believe one's childhood shapes his or her choice of materials. By using the materials one is subconsciously drawn to, one can elicit a wide range of fruitful associations. For me, it was exploring the underbrush of my hometown in North Carolina, a place where tree limbs intersect and where one can imagine in the mass of winter twigs, all kinds of shapes and speeding lines. When I turned to sculpture in the early 1980's, it seemed easy to call up the forces of nature and incorporate the sensations of scoring, sheering, and twisting into the surfaces of my sculptures. The saplings, so plentiful along my driveway, became the raw material with which to sketch out a series of large gestural forms. Using the shafts of a branch one way and the finer top ends in another, I developed a decade of work that I have come to think of as shelters of transition. Rather than existing simply for viewing, many of these sculptures present opportunities for reflection and contemplation, as physical places that can be entered, marking the moment when transitions and important life decisions are contemplated.

The need to accumulate and shape sticks and branches into shelters, nests and protected places has inspired various builders for the last two million years. The hunter-gatherer instinct lurks just below the surface of my consciousness, and this urge is manifested in the universal building compulsions of childhood.

In the early phase of a project, I visit the site. I rely on my own first impressions of the space, trying to remain open, testing various alternatives suggested by the site. Much like a bird, looking for a crack or crevice in a wall to support a nest, I carefully evaluate how I might intertwine with the architecture itself, to further a sense of reciprocity with the site. Before I developed the large gestural forms that are characteristic of my work, work that I think of as large three dimensional drawings, I had to discover what the birds and beavers already knew, that saplings have an inherent method of joining. If a shaft is bent, its stiffness can be threaded into and through a matrix, then released, so it will spring and hold tightly in the correct position.

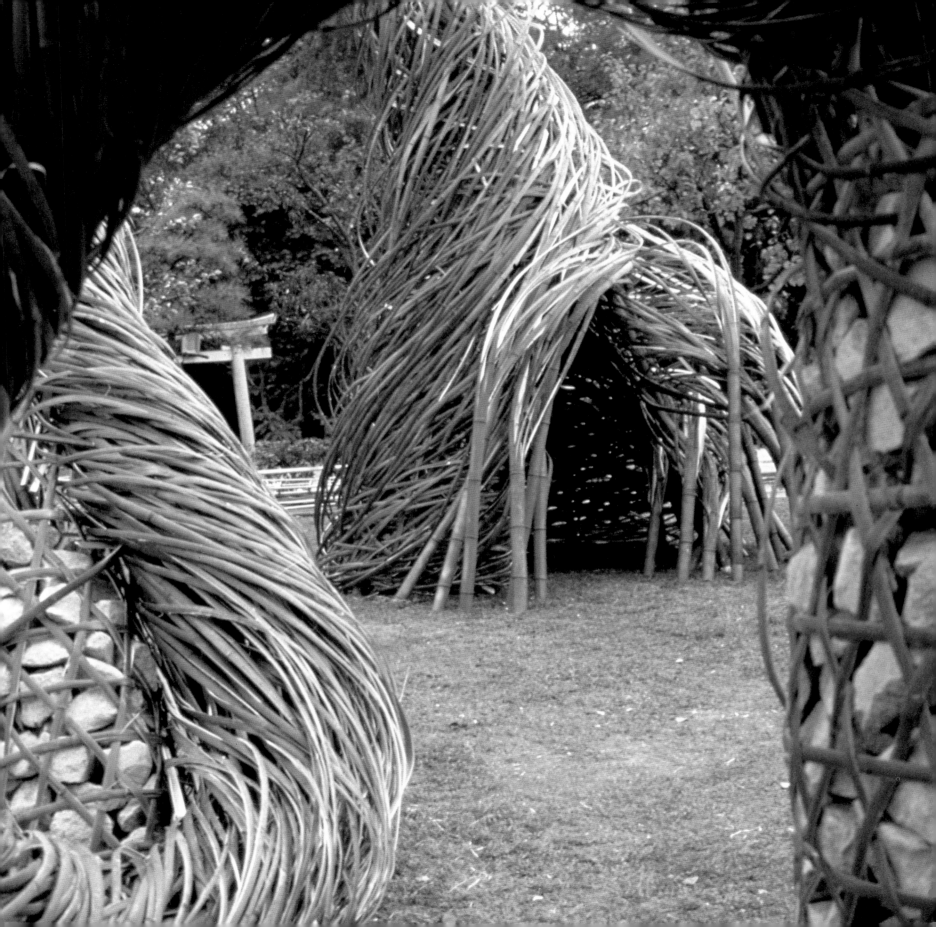

Next, I make a series of word associations with the space in which I will work, writing down whatever comes to mind. On the basis of these evaluations, I make a series of thumbnail sketches, not line by line renderings, but suggestions of the concept that can spark my imagination at the time of installation. Finally, I develop a rationale for making this particular work. The finished sculpture does not reveal this tale, but it is a method for focusing my own inner feelings on the work. An artist's life is usually the starting point for an artwork and the artist plays out an inner psychological drama.

Sculpture that responds directly to the site is site specific and was not part of my original vocabulary. Early in my art career, I was asked to have an exhibition. After designing a sculpture big enough to give the space the kind of visual excitement it deserved, I realized that such a large object would not fit through the door. I asked if I could bring my materials with me and construct the sculpture on site. Now I arrive at museums and galleries with materials by the truckload and adjust the scale to fit the dimensions of the space. Most installations take two or three weeks and during these eight hour work days, I meet the users of the space and am able to react to all the subtleties of the given situation. I feel and study the site in the presence of the growing sculpture and, as awareness accumulates, I react to and fine tune the sculpture itself.

During the construction, there are no studio doors to close, no place to hide. The public has access to the process and the work is completed in full public view. For some artists, this would be invasive, but for me it is exciting. I am reminding people that art is a normal activity. I look at these conversations as cultural interchange and feel that the sense of place and its people are somehow translated through this interchange into the final product.

And how do I know when a piece is finished, when it is really time to say goodbye? As I set parameters for an artwork, they continue to narrow. There is gradually less and less to do. I begin in a gross manner to get an overall design and structural integrity before applying movement and expression. I then go back and fix up rough areas, continuing to polish or gradually refine a piece. At a certain point, I achieve such a fine polish that additions will not improve the piece and then I stop. The three stages of my thinking are: structure, aesthetics and, then, cosmetics.

I find myself romancing the temporary and playing with the tentative. I am fascinated by the intricacies and subtleties of belonging and of having to say good-bye. Temporary is a touchstone for my belief in the vitality of process and the activity of renewal. It doesn't leave much for history.

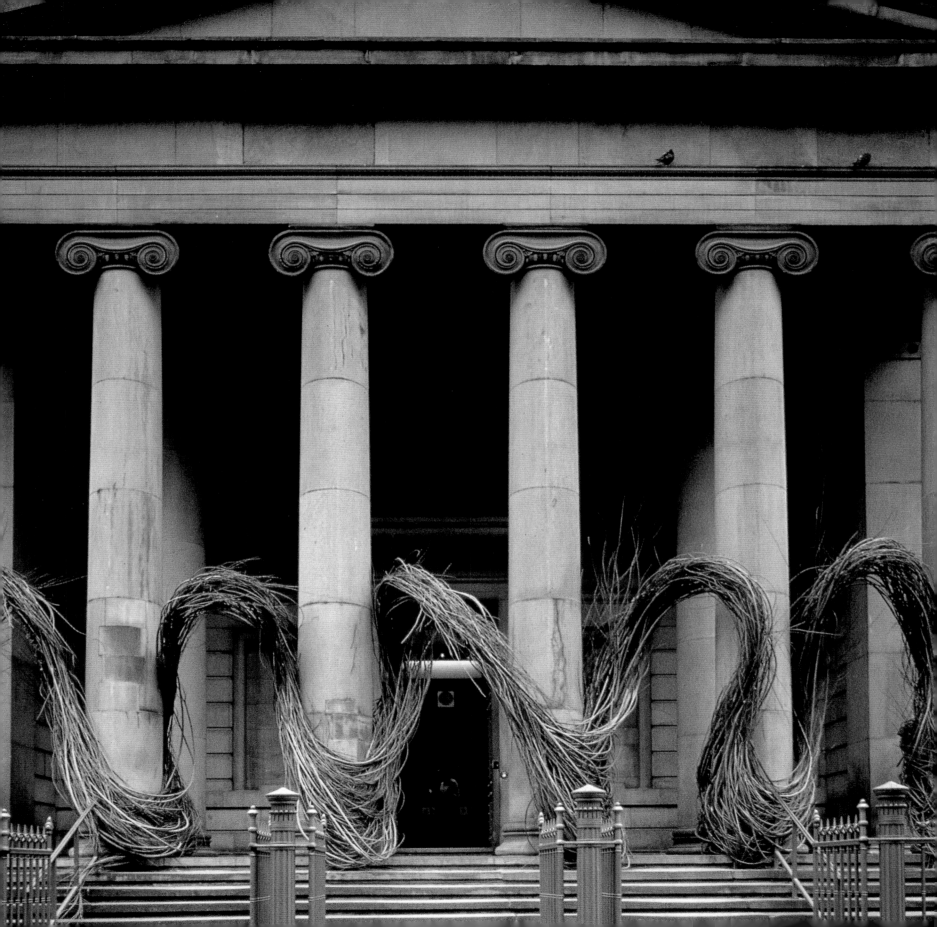

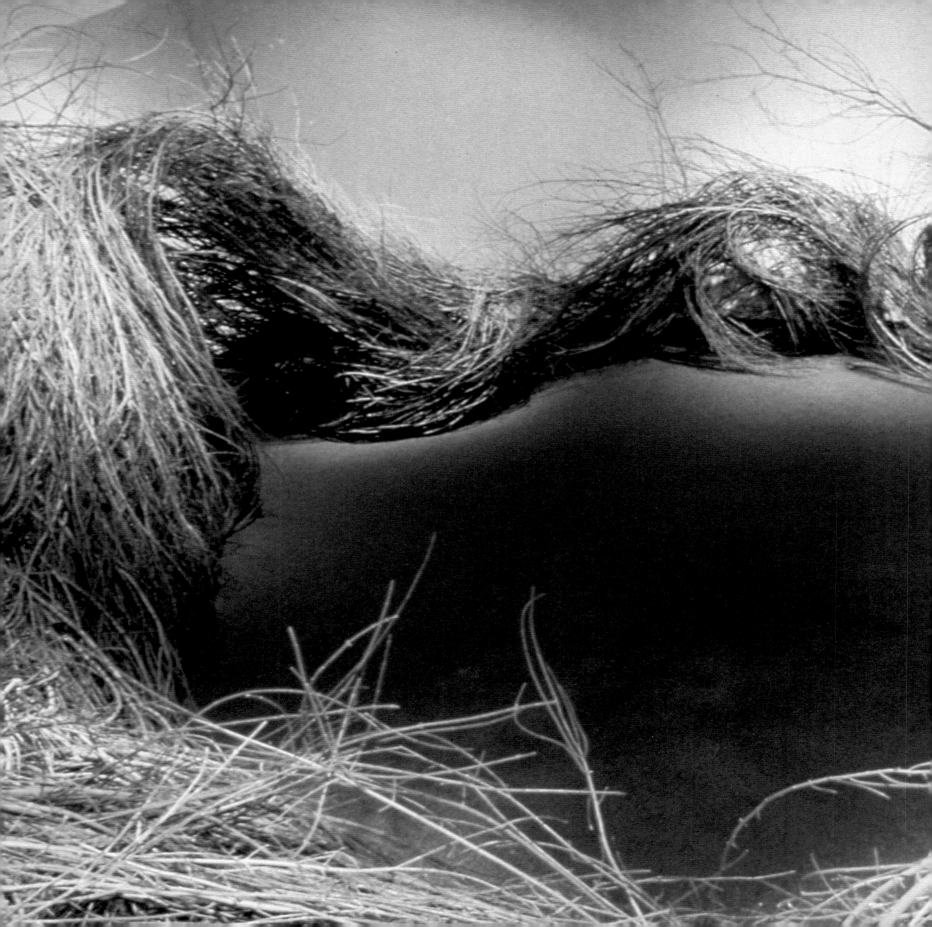

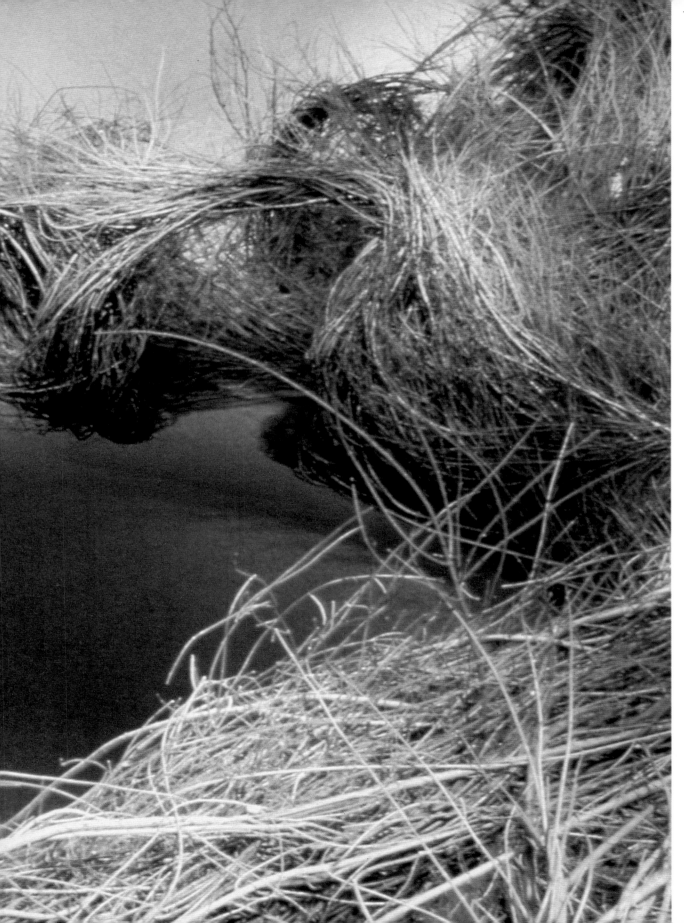

patrick dougherty

process: weaving branches
practice: romancing the temporary

Patrick's work reveals a spontaneity of art in process that is shaped by time and weather long after completion. In an effort to reconcile the man made and the natural, he uses ancient processes of construction, always sculpting with saplings indigenous to the place where he is working, and establishing a reciprocity with both place and space. He enjoys interceding for the arts, demystifying the creative process by working in full view of the public. Direct feedback from viewers is important and satisfying for him. He often has running conversations with passersby during his two or three week installation periods. Patrick's commissions take him around the globe, but home is North Carolina with his wife and young son.

plates
1. No Such Thing as Nervous, 1990, maple, detail from Broadway Windows, 8'x10'
2. Untitled, 1992, bamboo, 20'x50', in collaboration with Tsutomu Kasai, Misima, Japan
3. Rip Rap, 1991, willow, 50'x14'x3', Manchester City Art Gallery, Manchester, England
4. When Push Comes to Shove, 1994, maple, 35' diameter, South Carolina State Museum

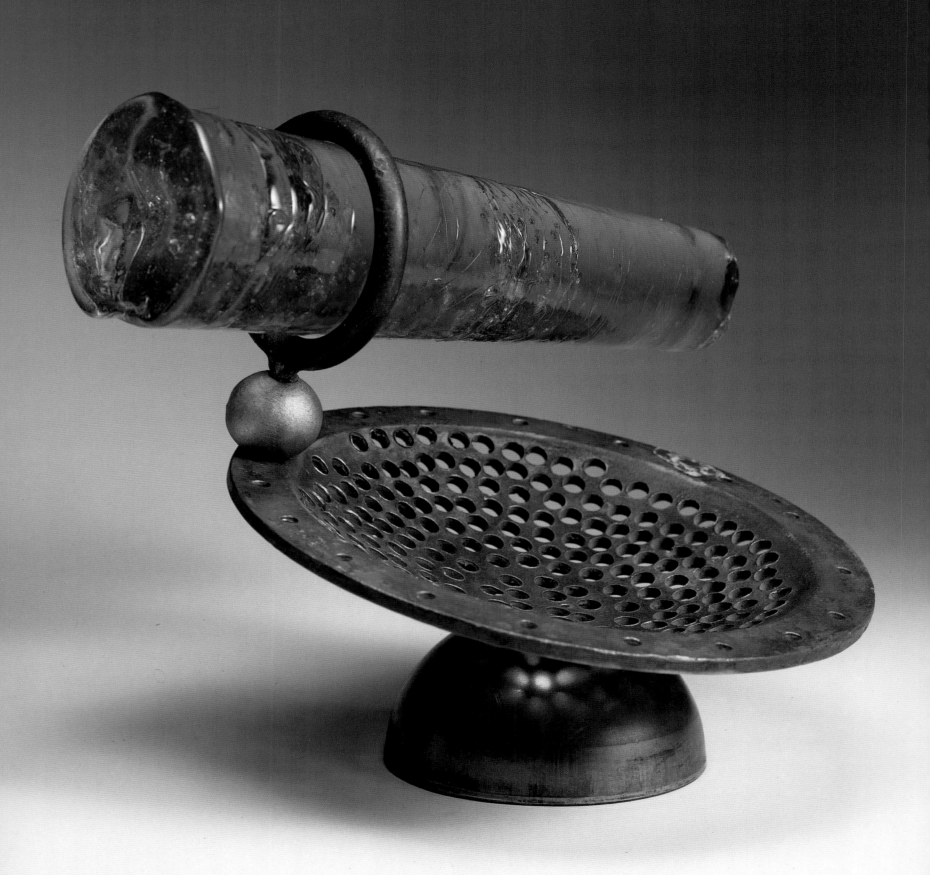

ann**sperry**

engaging form&**space**

space is made of glass
glass is made of air
the lightest sounds build
quick sculptures
echoes multiply
and disperse them
octavio paz

I start with air, I start with space, with open space. For me, air and space have materiality. They have volume. They are alive, pulsing with possibilities, fluid bodies of weightlessness that are in themselves weight bearing. Space becomes an extension of myself, and then, as I add shapes, it becomes a part of the sculpture, and ultimately space and shape interact and transform each other.

The spaces that have inspired my work have changed through the years. They seem to swing back and forth between the intimate interior spaces of our bodies and the exultant outward spaces we inhabit with our gaze. Inner and outer, outer and inner; we exist within space and displace space.

Biology took over my body and my sculpture during my pregnancies, and for the only time, my mature work became realistic. I made a group of sculptures that literally grew from my most intimate interior space: babies emerging from the womb, arms, legs, and heads, cast from found discarded doll parts, entering into our world. These "Emerging Forms", as the series was called, grew from my need to deal with the uncertainty and unpredictability, the fear and the joy, the energy generated by conception, pregnancy and birth.

The series that followed contained a different kind of emergent form. My first trips to the Southwest and the Rocky Mountains forced me to look outward. Having grown up on the East Coast, I was overwhelmed, during my first trip to the Southwest and the mountains, by the space— by the endless vistas of canyons and mesas, basins and ranges, by the towering curve of the sky that created a space, a vaulted space that became tangible for me. The resulting group of landscape sculptures were named for the spaces that captivated me: Havasupai, Bright Angel, Farthest Rim; endless spaces that redefined space for me.

"Personal Interiors", a series celebrating the inner workings of the body, followed. My pendulum had swung back once again from the vastness of the Grand Canyon to looking within. I had been contemplating humanity, but had no desire to make sculptures of people. Instead, I began to focus on inner space, those spaces that are occupied by our hearts, lungs, kidneys, ovaries, spleens, arteries, veins; spaces that are constantly pulsing, pumping, energizing; spaces in continual motion, spaces that create our inner rhythms, spaces we never see, spaces that we desperately need, in order to survive.

In our present time, the galaxies are beginning to reveal the secrets of outer space, true outer space, the space once relegated to comics and sci-fi. This infinite-seeming space is now a part of our world. Galaxies are born, stars and nebulae appear in spaces we thought never existed; planets and moons revolve in fixed orbits. All is as it should be, yet if one of the planets leaves its orbit, chaos will ensue. In a sense, we are all at this edge. "Out There", my recent series of sculptures, invokes this space, this continuum.

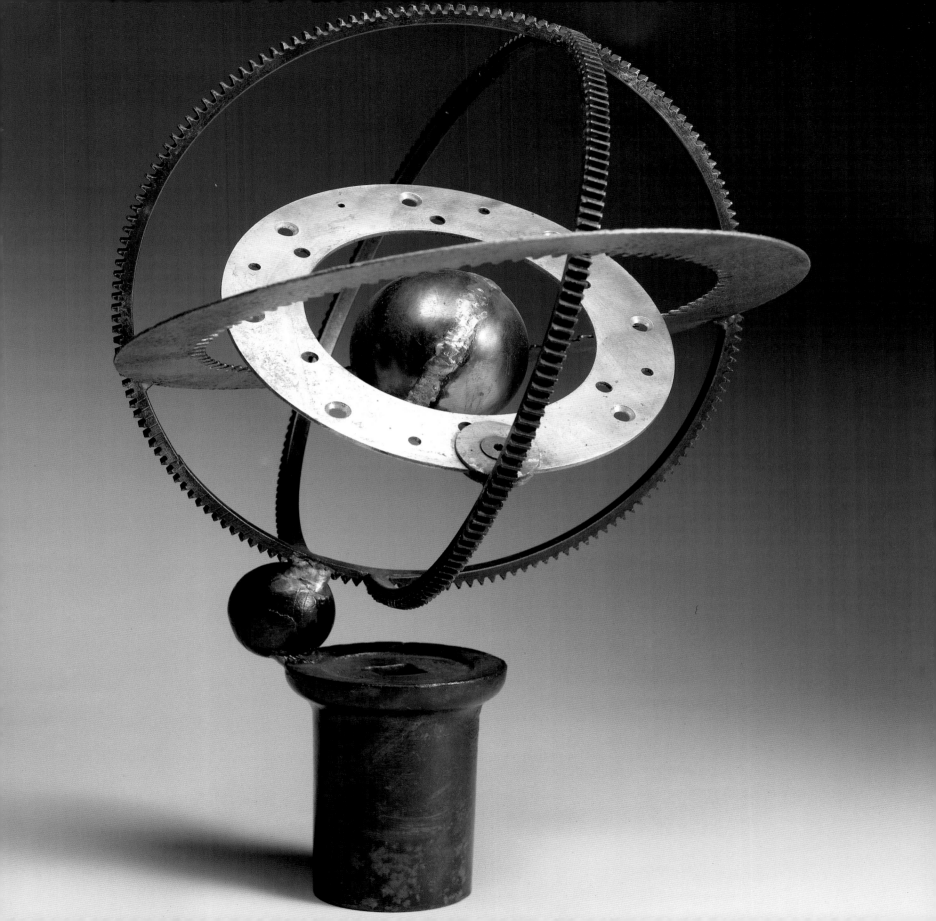

My creative process began in the bedroom of our Bronx apartment that was also my mother's workroom. An old Singer sewing machine overflowed with her projects. She made clothes for us; jackets, shirts, pajamas and ties for my father; curtains, slipcovers, bedspreads for the house. Scraps of fabric were always on the rugs and floor. Often she took me with her to hunt for fabrics. It was a time when remnants were all she could afford. We plowed through rolled up bundles of cloth wrapped around the middle with a strip of brown paper. The material tumbled out when you pulled one end of the string that tied it all together. We searched through boxes of lace, trimmings, scraps of fur, end pieces of embroidered ribbons; all discards that cost only pennies.

There was a tangible challenge and excitement when my mother started to make something. Almost always, the pattern called for more yardage than the remnant contained. She hovered over the fabric on the floor, clouds of pattern pieces surrounding her, tape measure draped around her neck, folding and unfolding in every conceivable way until she had manipulated the two-and-five-eighths yard remnant, transforming it into a three-and-a-half yard skirt. It was magical to me; she could make something out of anything and nothing. I could almost see the fabric grow to fit the need.

My studio is an inventory of odd metal shapes, a repository of old farm implements, obsolete naval objects, industrial debris, the remains of machines of unimaginable functions. Stacks of curved old pipe lean in the corners, boxes of odd-sized bolts and washers line the walls. Obsessed with intriguing looking piles of roadside debris, I pull over on my way to the beach on a hot muggy day, trying not to stab my sandaled foot as I dislodge a compellingly-shaped rusted iron bar.

Back in the studio, in my own open space, I place and clamp and reclamp metal shapes together, manipulating, arranging, transforming them until everything fits. With my welding torch, I make the space my own. The steel moves with the heat from solid to liquid and magically back to solid, as the sculpture cools. When steel is the right temperature, it bends like spaghetti; and with it I draw lines in space that remain forever.

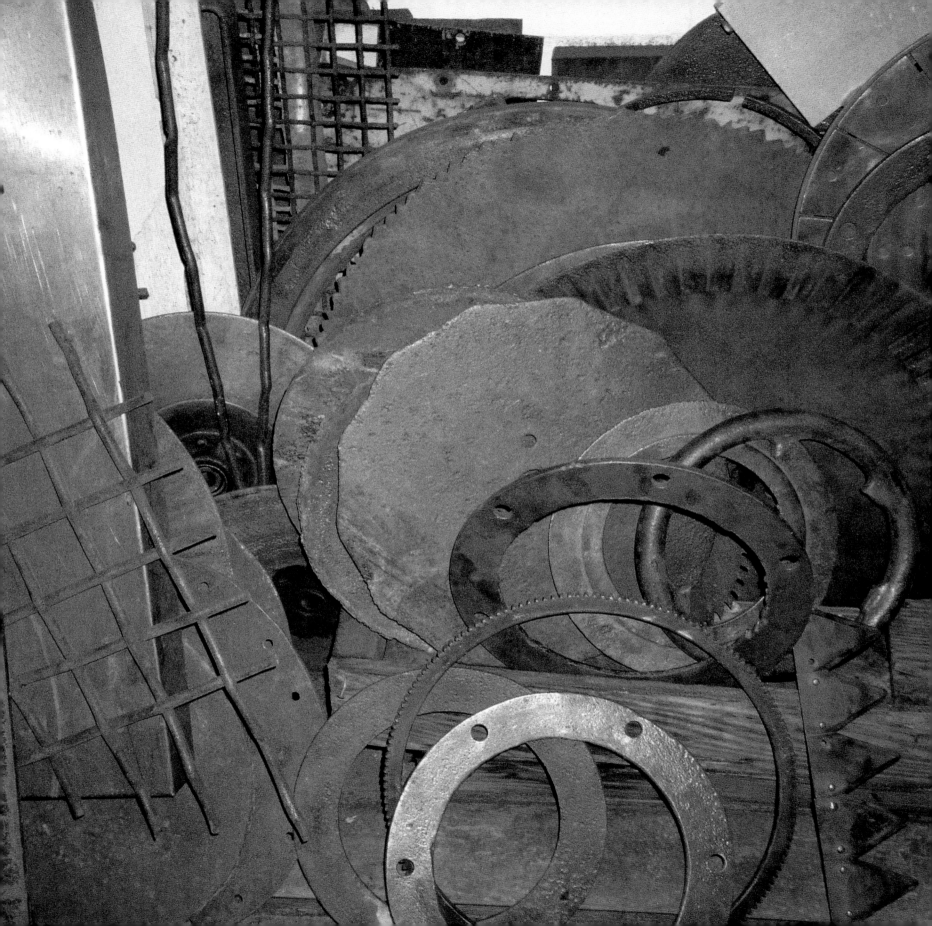

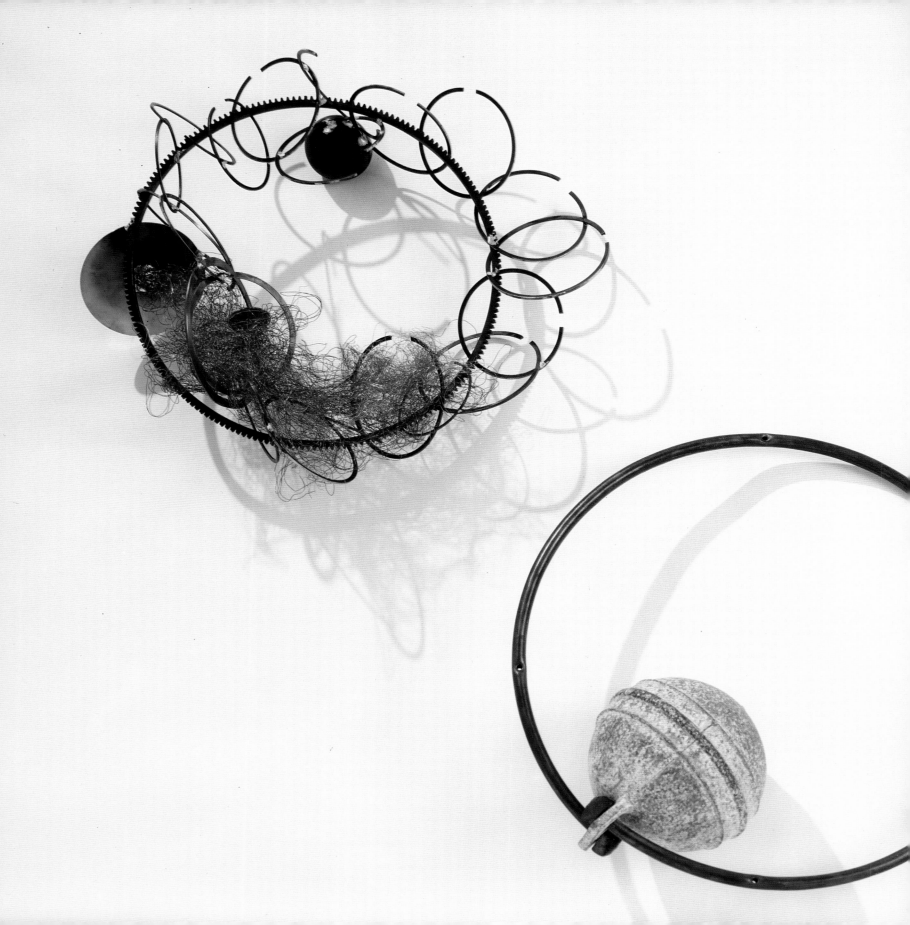

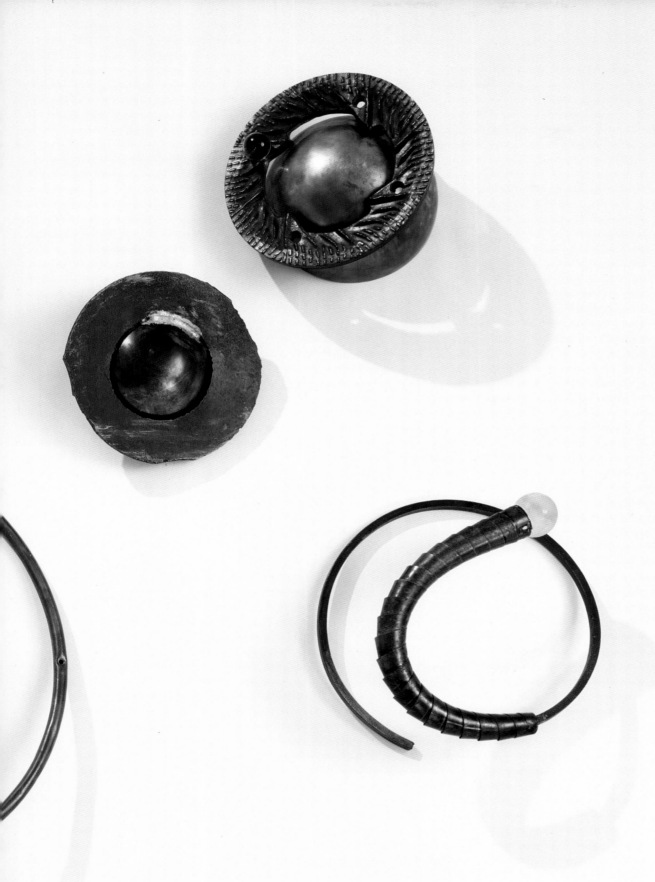

ann sperry

process: welding
practice: seeking the interspace

Much like a physicist, Ann deals with the larger universe, its vastness and the miraculous nature of the cosmos, of which we are only a small part. Ann's early work focused inward on herself, but she has moved to perhaps the ultimate outer focus, our galaxy. Her sculptures, all of which are based on curvilinear forms, seem to hold and attract light. They are both self sufficient and interactive with surrounding space, creating for a viewer an increased spatial awareness. Ann sees the supposed vacuum of empty space, out there in the sky, as filled with energy. Recent work captures that energy and reminds us that we dwell in a cosmos of subtlety, scope and power. Ann lives in New York City with her husband.

plates
1. **Out There XVI,** 1995, steel, brass, glass, wood, 13"x14"x11"
2. **Out There XV,** 1995, steel, brass, 21"x7"x15"
3. **Ann Sperry's studio,** 1995
4. **Out There Series,** 1995, size varies

Place impacts all the senses influencing who we are and will become. The places where we travel, mentally and physically, set the scene for a life long encounter with the authentic creative self.

I explore substance and spirit, art and artifact.
allison stewart

...and so I go to Africa. I am the white canvas and carry a mirror.
nancy head

It is only by disassembling a place, ingesting its sounds, textures and smells, that I see what cannot be seen.
lynn heitler

My work in fiber is about giving presence to a whole new way of seeing.
lewis knauss

placesknown & unknown

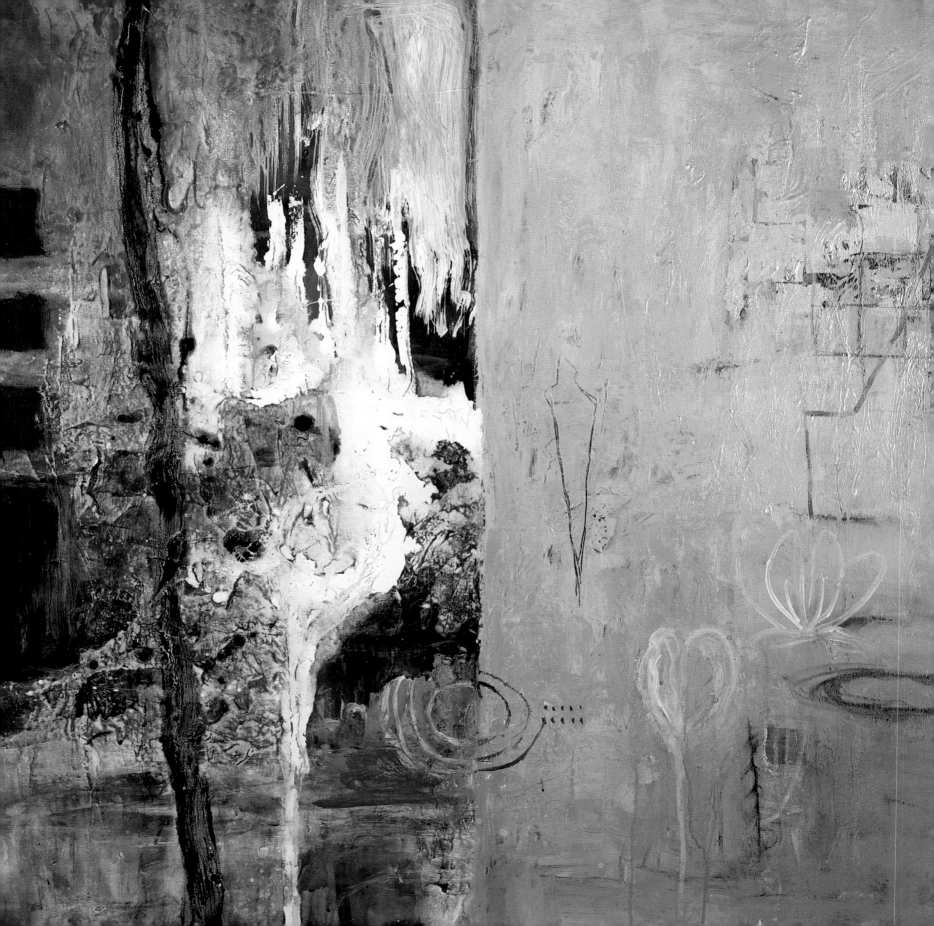

allison stewart

exploring sacred places

touching primal memories
with a momentary sense of recognition
connecting to other cultures and times
accepting the coexistence of
past and future
exploring a realm of shifts and changes
the gap between what I see
and what I know

Through the ritual process of painting, I connect with a world of magic and mystery.

My work is about a sense of place and the effects of time on place, but it is never a literal representation. My paintings are visual diaries, memories and notes of the real and imagined and the half forgotten. The physical landscape is often a starting point for my journey into the inner landscape of memory and imagination. I live in New Orleans, a city of the senses, full of elegance and decadence. Every surface is worn or embellished and every day is Mardi Gras.

I never intended to become an artist, but now I cannot imagine being anything else.
Trained as a biologist, I am interested in natural patterns and processes, life cycles,
and the interrelationships of living things. Extensive travel lies at the core of my process.
I collect tools and fetishes from all over the world: ceremonial blades from Mali, medicine
pouches from Afghanistan, bowls from Benin and raffia trading cloths from Zaire. I have
voodoo dolls, gris gris bags and root fans from the French Quarter, just ten minutes from
my studio. These weapons and trinkets find their way into my art, not simply as
interesting forms, but also as a means of making intuitive connections.

In these cultures, art is intrinsic and plays an important part in daily life. It is not a product
produced for market, but a process that puts an individual in touch with universal forces.
Monuments, amulets, beads, talismans, even found objects serve to connect people with
their beliefs and power.

My usual practice is an early walk through Audubon Park, an inner city oasis where I fill
up on nature in progress and where the light, colors, seasons are always changing. My
route is unvarying, yet the surroundings are in constant flux. Later in my studio, behind
closed shutters, engrossed in process, time stops, as I become totally alive, aware and in
the moment. I am in the act of transforming feeling into visual form.

It's an intuitive give and take process. The studio is both a workplace and sanctuary, a
place of solitude and retreat where I can listen and reconnect . I have the freedom to take
off and go to the edge . It is exhilarating, exhausting and fascinating, going beyond what
is known, moving into uncharted territory.

A painting evolves slowly, through layers of gesso, paint, charcoal, and glazes. I often
work on the floor, circling around, building up, scraping away, centering, focusing,
performing those ritual gestures that are part of my intimate personal process. Forms
emerge, becoming visual records of my explorations into substance and spirit, image and
impression, art and artifact. I layer, pour, draw, erase, work and rework until I sense a
balance. Plant fragments, blades, earth and organic forms appear, and in the best cases,
become totemic, lyrical, sensitive and exotic. It is an organic process, through which I
touch into who I am and how I relate to the world.

It is time to quit. I open the shutters, reenter the outer world, go home to cook an evening
meal of jambolaya with my family and listen to some good jazz.

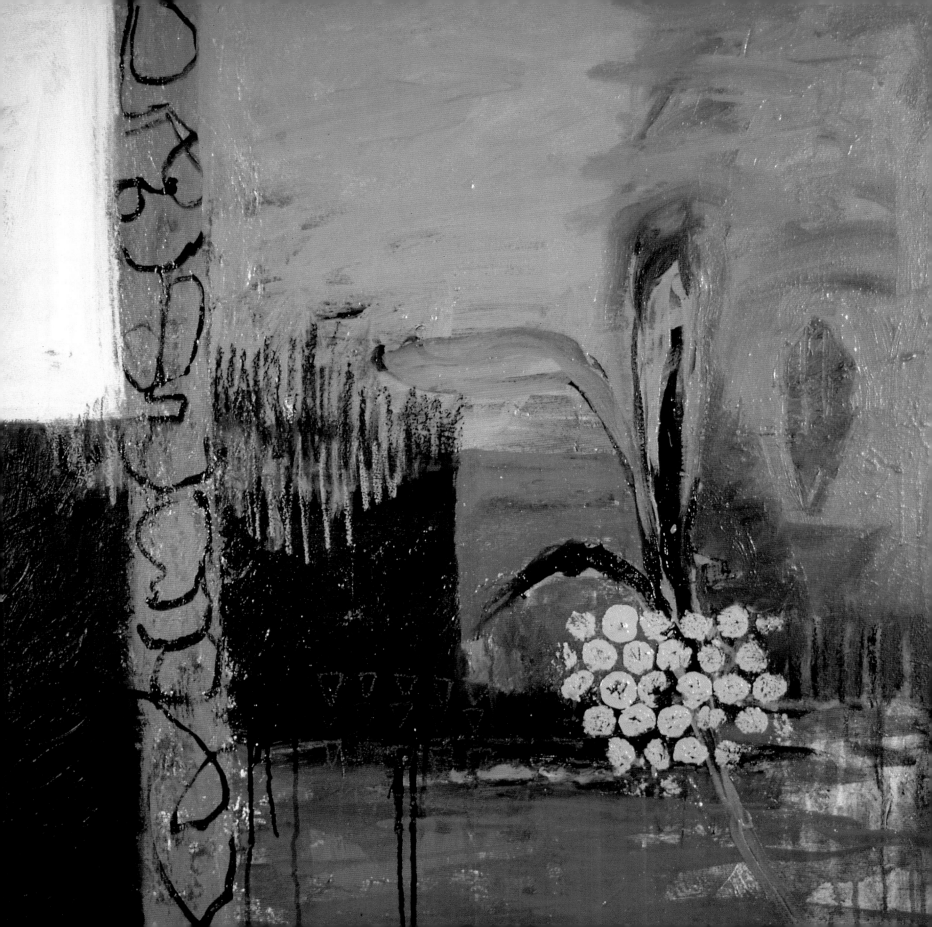

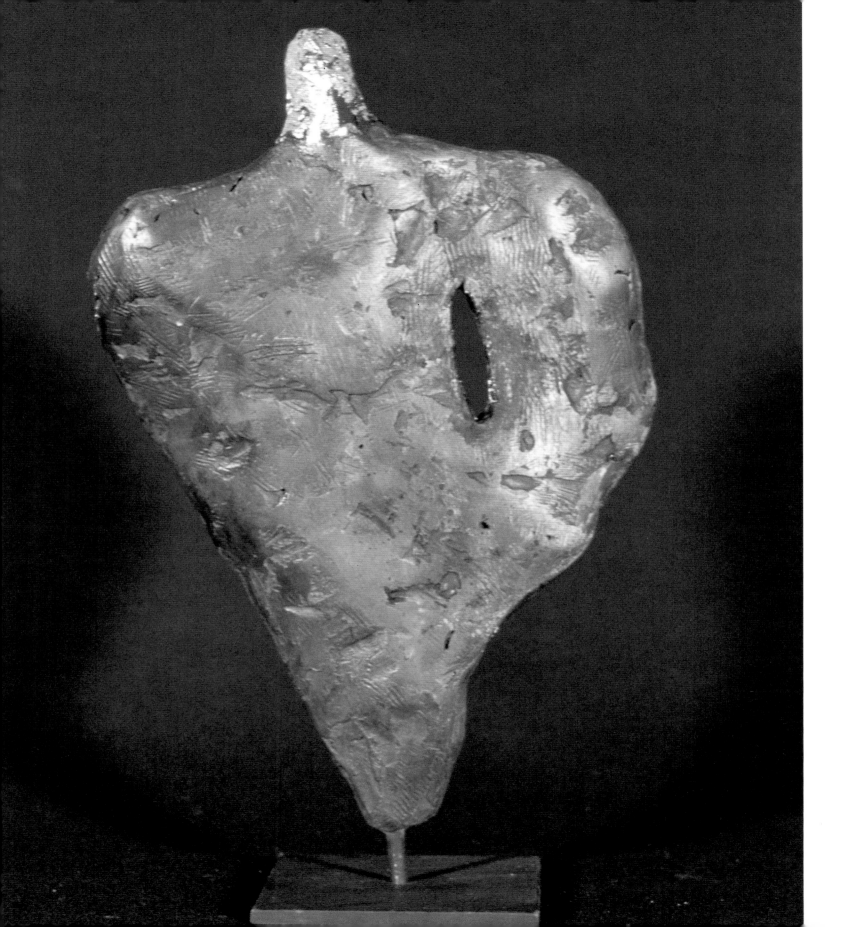

allison stewart

process: painting
a visual diary
practice: connecting with
the ancient past

It is through the creative process, particularly the personal ritual of painting, that Allison discovers deeper meanings in life. Her artwork seems both ancient and contemporary, physcial and spiritual. She paints on large canvases using personal notations to record her intimate journey. An abstract expressionistic style provides her with the luxury of free experimentation as she touches, marks and paints the surface of her canvases. The painted surfaces are achieved by applying many layers of color that are manipulated when wet, then scraped and sanded when dry, to yield a rich encrusted patina. Rather than anticipate results, she thrives on the unexpected and accidental. She also creates small stone sculptures that look like actual artifacts from an ancient culture. Allison lives and works in New Orleans with her husband.

plates
1. Intersection: Facing Winter, 1995, mixed media, 48'''x48"
2. Water Dance, 1995, mixed media, 60"x60"
3. Matrix Series: opal, 1994, mixed media on hydrastone, 18"x8"x3"

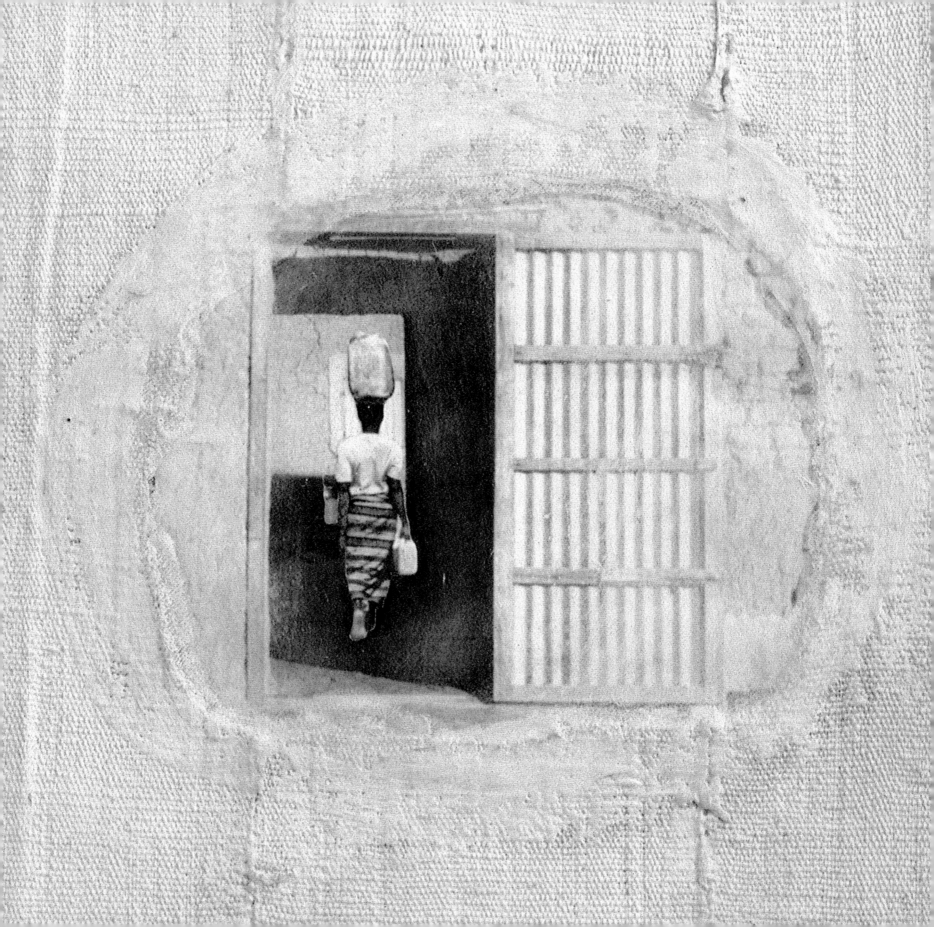

nancyhead

retrieving thesoul

reclaiming the soul
the vital essence
calling on ancient memories
reinhabiting them
learning that memory
is more permanant
than matter

The daily reality: I live my art. Everything I see, feel and do feeds into the next image-making event. Reflections, continuously bouncing from object to observer, are uniquely twisted, flattened, expanded, scrambled or chopped. My work is to review, reconstruct and render images that carry curious, honest information with emotional and aesthetic sensitivity. Like the days of my life, some will carry more satisfaction than others.

initiation: In the beginning I painted with watercolors. I took drives, parked my car and painted the landscape. A storage shed became my studio. It was a purely funky seventies remodel, small, inconvenient and charming. The creative muses moved in with the monsters. It was too crowded. I designed a new studio with careful, selfish, driven love. It is big, modern, convenient and spiritual. There is room for everything and everything moved in. It is dedicated to creativity.

the journey: There are no excuses. I tell myself: "You must do the thing you think you cannot do." Why am I groping with indecision? The dreams are safely snagged and pinned. My rational mind, the librarian to my artist soul answers: "Do the work, the rest will follow".

I am ready for the journey. All the fears deterred as expectations crowd together to link hands with courage. I remind myself that I must do this. The place I live gives me a landscape rich with redwood forest, wild rivers, lush farmland and the ocean rules. But swimming in a green sea can be exhausting.

And so I go to Africa. I am the white canvas and I carry a mirror. I gather images. I have unlimited storage for interesting images. How many ways do we collect water, adorn our bodies, perform our rituals and include each other? This is the art of living. I've never felt so focused. Hot, red dirt, black skin, vibrant colors, laughing, languid, many-voiced market, odd smells, bayobob trees, dry, mosquitoes, riverboats, villages, working women, children wanting, termites, painted huts, poverty, disease, joy and everywhere rich in art.

return: Home again. My studio. It feels unfamiliar. I begin looking through drawers, pulling out old art, ugly work, some interesting things, beach pebbles, string, sections of rope, scraps of silk, sticks and candles. It's messy and I mess around. I clear a spot, open the clean page, scribble, scratch and dig for a thought. Mindless, I am searching, traveling through a strange land. I stumble onto something. It is a beginning and I snag it with the instinct of a hunter. I will build a book.

The African Book: somewhere along the Niger river in Mali, a small boat slips through the crack, between a stage and dreams. The sun with fire has glazed the evening sky above a smoking red shore. I step into this space where black children scramble to meet the white ghosts.

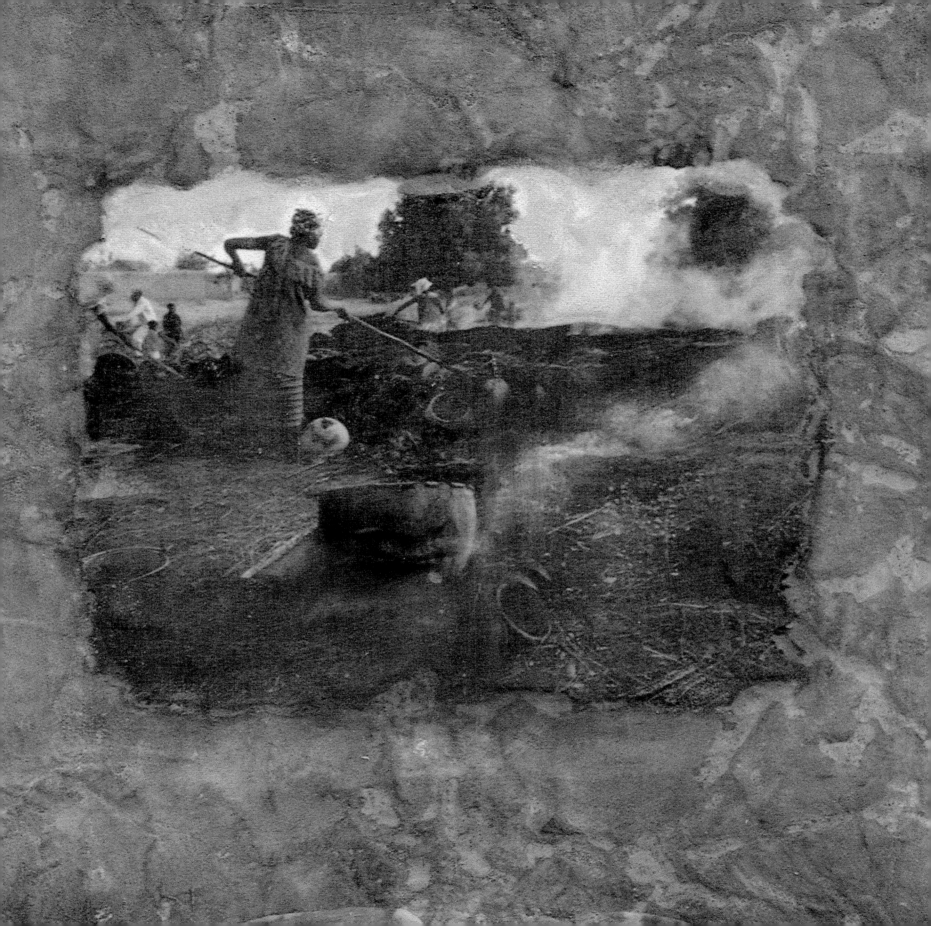

Hand in hand, we climb the bank to reach the village, Kallabougou, where the women are potters. A thin veil wraps the charred black earth as figures dance around the glowing, breathing, smoking and pulsing center of a dreamscape. To and fro they move, with strong arms the long poles lift the smoldering black globes to dip and rest in careful rows. As the women work, children look. They are precious, innocent, watchful, brave and wise. I gape, grope and plead for camera magic. Swirling and clicking, the dreamer jumps in and spins to timeless steps as the river is forever flowing.

An image emerges on the surface. It is stolen, rescued, restored, restolen again and again. It is arranged, rearranged, removed and replaced. It is like a misplaced person trying to find home; someone with insomnia, someone both very young and very old. It can be nonsensical and alluring. The ingredients of life happen. Control is minimal. There is elation and depression, high energy and complete exhaustion. The artist is out and very much alive. The creative mind has no boundaries. Imagine being limitless in any area of life and you have imagined art. For me, it is the journey that I can never stop pursuing. Layer after layer of history in color and shape slyly steps forward as the story unfolds with whispers and screams.

Focused in my studio again, I paint a little map of the big earth. Tree branches form boundaries that guide the eye and tell the brain there is a message. This is a curious squatting to find the blackberry, from perfume rising with the ripening sun. Some spaces shout and pulse to be seen in crowded color while ragged edge meets creamy rocks in wooden cradles. These are alluring places to be probed: a journey requiring nothing more than interest, a place where information stands in close quarter with adventure so you won't get lost for long. Death is safe after all.

Life, what does it mean to me? Everyday, doing whatever I do, as well as I can. Remembering that my time here is brief, without feeling terrified, is a daily lesson. Keeping sacred my dealings with each person in my life, caring for everyone at some reasonable level in terms of commitment, leaving time to care for myself. Art is a spiritual outlet for me. How? In the search for more visual ways to communicate, digging deep inside, I have consistently been given surprises. Gleaming, groaning, and sometimes grueling results, usually something new to me, always learning, bit by bit, shape by shape and color by color, I am becoming...

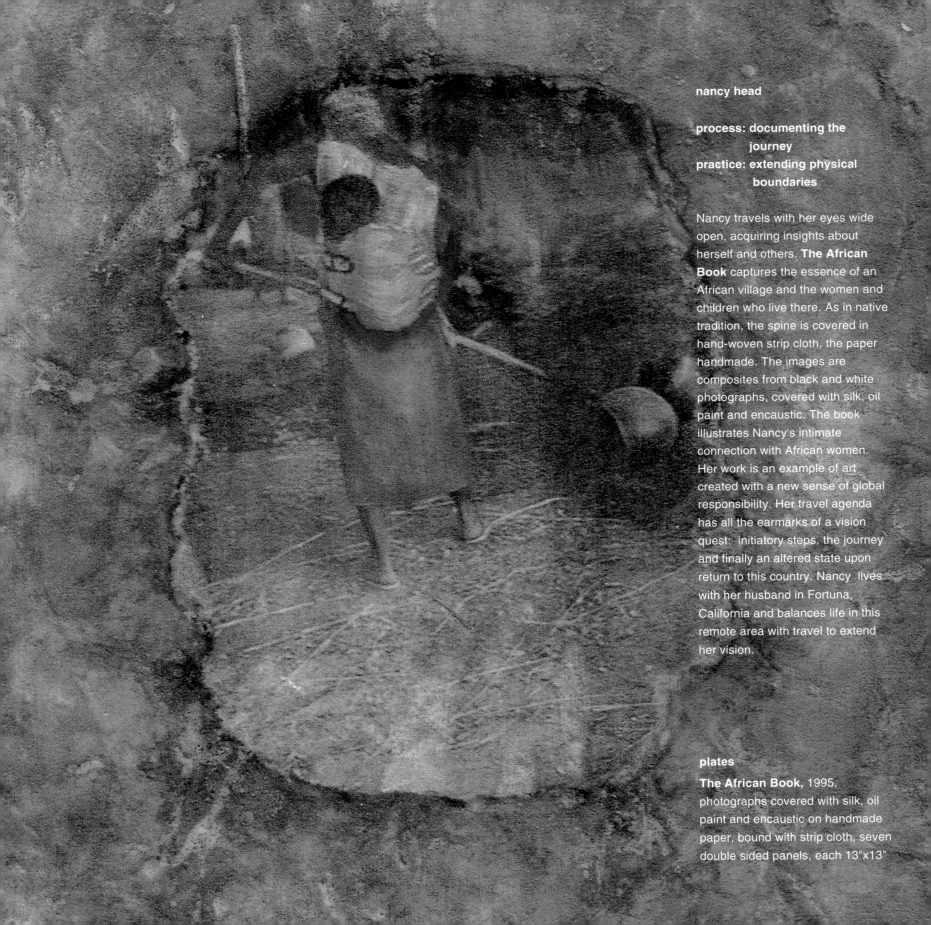

nancy head

**process: documenting the
journey**
**practice: extending physical
boundaries**

Nancy travels with her eyes wide open, acquiring insights about herself and others. **The African Book** captures the essence of an African village and the women and children who live there. As in native tradition, the spine is covered in hand-woven strip cloth, the paper handmade. The images are composites from black and white photographs, covered with silk, oil paint and encaustic. The book illustrates Nancy's intimate connection with African women. Her work is an example of art created with a new sense of global responsibility. Her travel agenda has all the earmarks of a vision quest: initiatory steps, the journey and finally an altered state upon return to this country. Nancy lives with her husband in Fortuna, California and balances life in this remote area with travel to extend her vision.

plates

The African Book, 1995, photographs covered with silk, oil paint and encaustic on handmade paper, bound with strip cloth, seven double sided panels, each 13"x13"

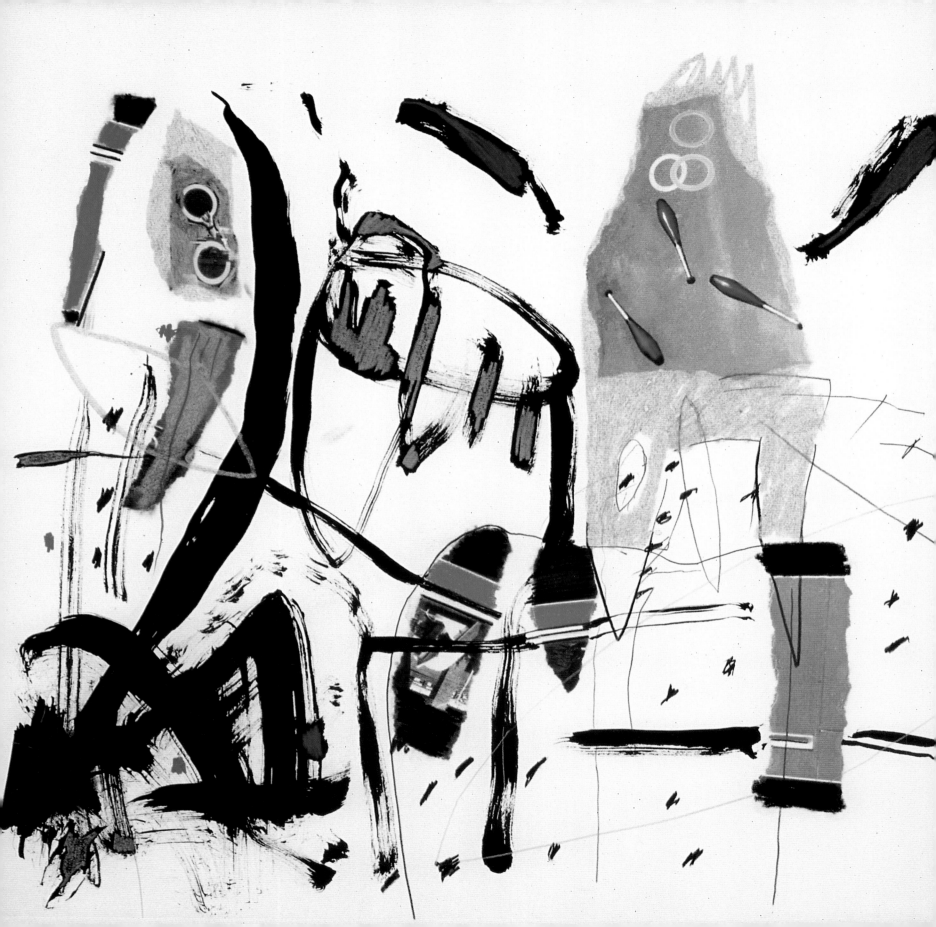

lynn heitler

abstracting a place

As if in a dream, memories and images of place come together. Unrelated images express thoughts that access personal meaning and place becomes a medium of aesthetic experience.

It has taken years for me to realize that the ability to access the images inside me, to create in a suspended state of deep intuition, is a special gift. Painting the images of actual objects usually leads me further away from, not closer to the true essence of the thing on which I am focusing. When something recognizable, like a flower, appears in my work, I often obliterate it in an attempt to capture the object as I feel it. Realistic images carry too much baggage. Identification with discernible objects tends to predetermine or even confuse meaning in an artwork, instead of opening me to a visceral experience that has an emotional impact.

I begin a print project with photographs I have taken of a place: perhaps graffiti on a wall, an architectural detail, a pattern created by reflections or shadows. The photograph may be a literal view or an abstraction, but it is always part of a journey toward clarification and honesty. For example, drops of rain clinging to a car window provide an image of my experience in Seattle. I am seeking to capture the essence of that city as defined by water, salt in the air and a unique quality of light as it diffuses over the city.

Similarly, calligraphy carved into a luscious green stone in Xian, many centuries ago, can contain an element of my feelings for China. Eels in the market place, birdcages, doorways, all become a feeling-collage, an assemblage of experiences that have touched my unconscious. It is only by disassembling a place, ingesting its sound, texture and smells, that I see what cannot be seen. I take apart my photographs, obscure them, rework them, until they speak to me in a new way. Like the perception of a sigh in the dark, I form a new image mostly by feel and by using a kind of peripheral vision to translate my experience. The end result is a distillation of place.

I am not an artist who, inspired by an idea, proceeds systematically. Instead I rely on intuition, on internal guidance. I often leave home to print. The preparation for these trips is detailed, fearful, and exhausting. I prepare weeks in advance. Pencils, inks, brushes, and paper are selected and packed. I usually end up with more than I can use in one printing session. Emotionally, I am a wreck. I anticipate disaster. I am like a symphony conductor standing before an orchestra without any music. The blank paper awaits, like expectant musicians ready to follow my lead.

Almost magically, the music comes to me. Initial marks or images are put down. I proceed through problems of balance, color and an endless dialogue between mind, hands, and paper. I am fearless and will obliterate major sections of a piece to study how this alteration will affect the work as a whole. A print is composed of five, six or seven layers. Each layer covers up or enhances an element in the work beneath it. This gives me space to reveal whatever I choose. The hidden layers are a personal, psychological drama, reflecting my own unconscious. This mixture of self awareness and deep relationship to place, gives my work its idiosyncratic quality.

I have very little attachment to the prints once they are completed. It is the process that captivates me. The act of creating is a personal meditation where time has no meaning. Nothing matters except engaging the work. Practical matters of daily living melt away as I focus my attention, almost hypnotically, on the process. Weeks of preparation, fear, years of working through paintings I later detested, of struggling with the demands of the world for time to work; all this slips away. I lay down marks, clumsy at times, a calligraphy of my unconscious. I am amazed. Colors, patterns, surfaces emerge like unexpected expressions on the face of someone I thought I knew completely.

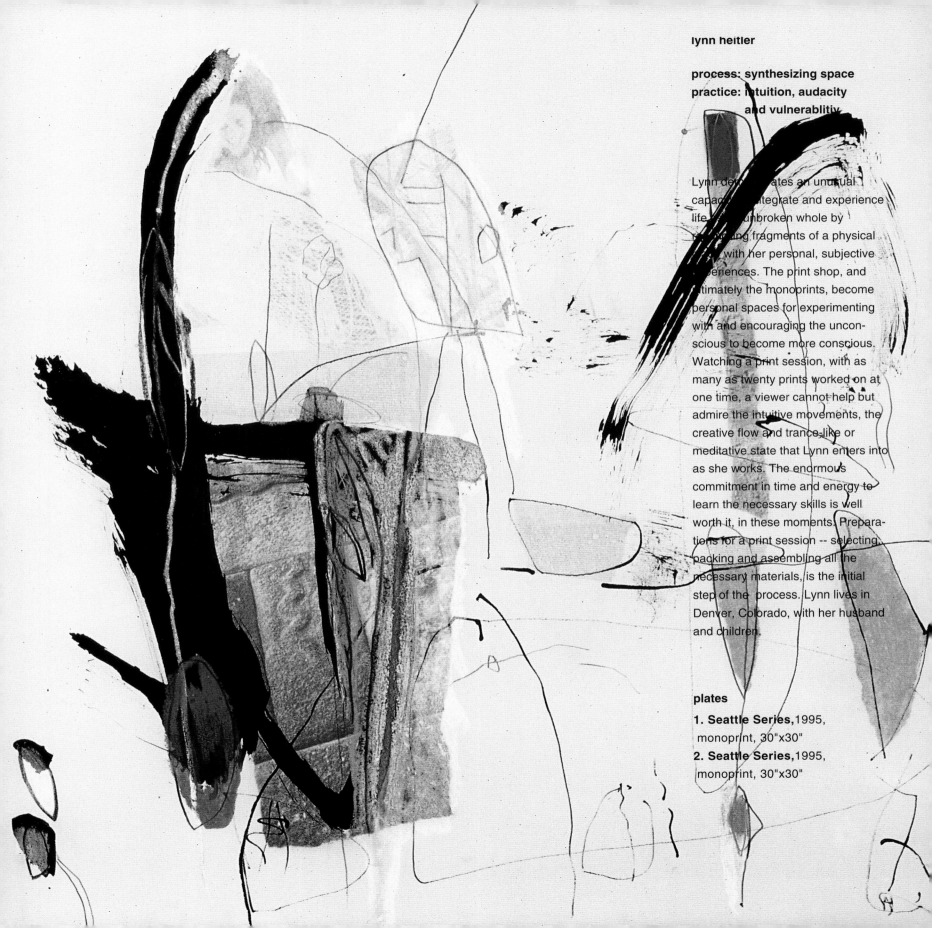

lynn heitler

process: synthesizing space
practice: intuition, audacity
and vulnerablitiy

Lynn demonstrates an unusual
capacity to integrate and experience
life as an unbroken whole by
integrating fragments of a physical
space with her personal, subjective
experiences. The print shop, and
ultimately the monoprints, become
personal spaces for experimenting
with and encouraging the uncon-
scious to become more conscious.
Watching a print session, with as
many as twenty prints worked on at
one time, a viewer cannot help but
admire the intuitive movements, the
creative flow and trance-like or
meditative state that Lynn enters into
as she works. The enormous
commitment in time and energy to
learn the necessary skills is well
worth it, in these moments. Prepara-
tions for a print session -- selecting,
packing and assembling all the
necessary materials, is the initial
step of the process. Lynn lives in
Denver, Colorado, with her husband
and children.

plates

1. Seattle Series,1995,
 monoprint, 30"x30"
2. Seattle Series,1995,
 monoprint, 30"x30"

lewis knauss

recording the landscape

The issue in art as meditation is not what is being done or produced but the total presence of body and spirit in the process of creating

From the moment I first touched yarn and twine, I loved it! The repetitive, time consuming techniques suit me, almost perfectly. The ability to invent and feel an artwork develop, line by line, allows me to connect on an intimate level with my materials, feelings and a sense of personal vocabulary. Many non-western applications of these techniques for clothing, architecture and sculpture open further areas of exploration, especially when the idea of art is totally connected to life, a means of living, celebrating and releasing.

I am obsessed with knots. As life becomes more complex, I have discovered in knotting a meditative practice that holds a power, releasing prayer as I exist in my own quiet space. Rather than being tedious, the process allows me to focus and listen. I find not only a meditation, but a record of time, moment by moment, knot by knot, and also a record of my own life.

Living alone in an unfamiliar place in 1973, I felt a deep sense of loss. I had never thought much about my home town, but suddenly I realized the importance of place. I began recording impressions of my landscape as a child, using materials related to my upbringing, conveying the feel of that particular place and discovering in fabric a connection that had previously been lost.

Time passed. Subtle shifts occurred. Adrift. Less time for my art. A loss of connection, sensations of unresolvable sadness, the connection to landscape nearly lost in my work. There are no coincidences, but rather situations presented for learning. I was offered an opportunity to spend time in the mountains of Colorado. As I left, apprehensively, my recurring thought seemed to be: this is a chance to work on myself. At the time, I didn't know what that meant.

The new landscape was vast and, for me, incomprehensible. Wandering around in my east-coast mind frame left me feeling removed, as if looking at a postcard. I began to realize that in order to understand a place, one had to put in the required time to connect, visually and spiritually. I placed myself to see single elements: a line, a blade of grass, a tree in the forest, a new flower, a familiar place. Walking in the mountains, spending time seeing freshly brought me into connection with nature. I found things I had failed to notice in my frenzy to hold a job, create that resume, attend the required affairs. This was a chance to reexamine the landscape, its language and materials... a meditation in progress.

My recent work in fiber is about giving physical presence to this new way of seeing. I create impressions of landscape, line by line, first experiencing the whole scene and then becoming aware of the individual elements that create it. I am exploring quiet safe places, meditations and objects of meditation. I am marking time, time in the sense of seeing, time related to the creative process, time in a non-urban sense. This is a process and a space that allows me time to learn, accept and prepare for something beyond the obvious, that continuous visual cadence that I have always been striving for.

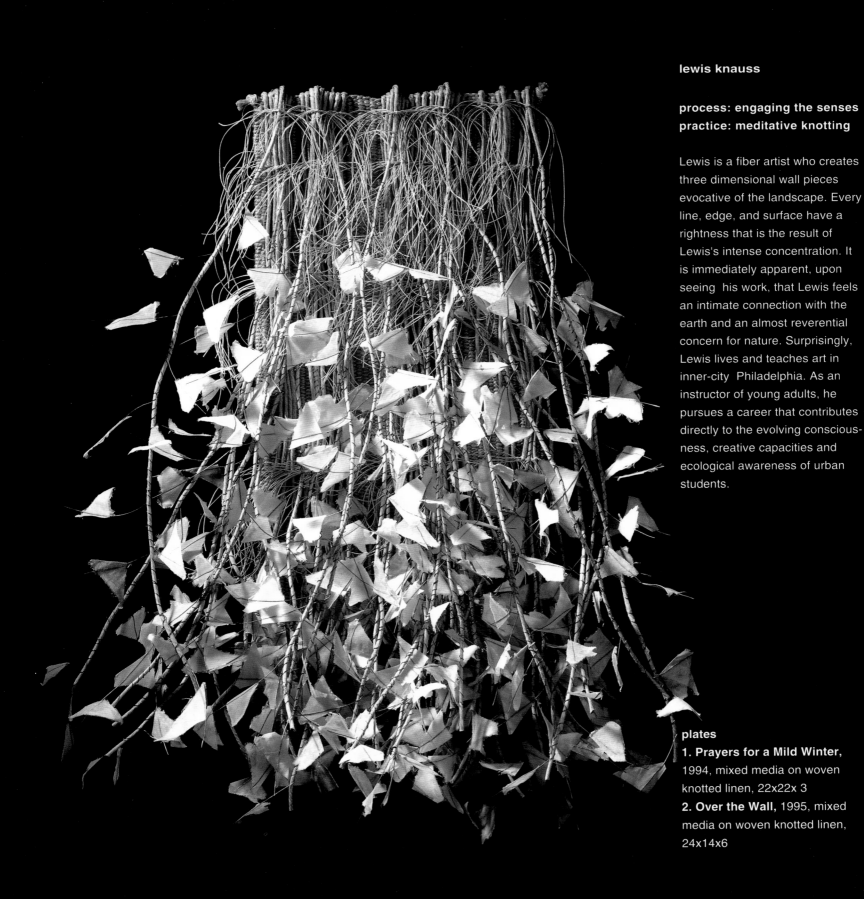

lewis knauss

process: engaging the senses
practice: meditative knotting

Lewis is a fiber artist who creates three dimensional wall pieces evocative of the landscape. Every line, edge, and surface have a rightness that is the result of Lewis's intense concentration. It is immediately apparent, upon seeing his work, that Lewis feels an intimate connection with the earth and an almost reverential concern for nature. Surprisingly, Lewis lives and teaches art in inner-city Philadelphia. As an instructor of young adults, he pursues a career that contributes directly to the evolving conscious-ness, creative capacities and ecological awareness of urban students.

plates
1. Prayers for a Mild Winter, 1994, mixed media on woven knotted linen, 22x22x 3
2. Over the Wall, 1995, mixed media on woven knotted linen, 24x14x6

The initial step, movement toward an unknown place, propels us toward an edge or the center, while the flow of experience carries us forward toward goals of which we are only dimly aware.

To begin the creative process, it is important to touch on something pure and simple, like running up a mountain.
peter stark

My mind never follows a linear path between ideas; everything is multidimensional.
augusta thomas

I prefer to create asymmetrical structures, because they accent the natural movement of people through space.
angela danadjieva

I am unable to verbalize what my artwork is about, but I know it is moving something within and it is unnecessary to name it.
linda aroyan

movement toward an edge

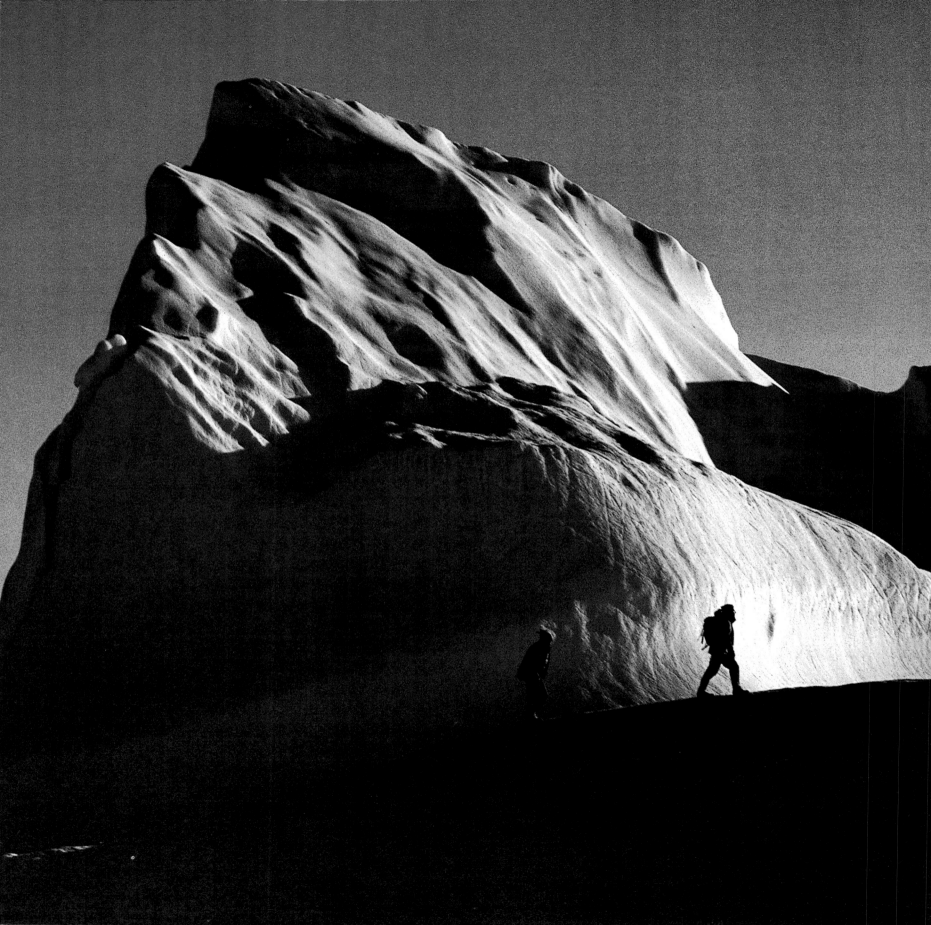

pete stark

playing at the edge

*I still love winter, snow and ice.
I love them more than I ever have,
but I see them differently now.
On their surface I've spread out
the chaos that was once my life
and assembled something
that approaches grace.*

After several years of writing about snow and ice and winter, it was no longer enough simply to describe my experiences, as I had when I started. I began to ask larger questions about them, to really **think** about them. Instead of close up, I stood way back and asked the questions that became obvious only from that distance: What is it about speed that's so compelling? What really goes through your mind as you're, say, skiing down a 45-degree slope or roaring at midnight across a frozen Wisconsin lake in an iceboat? What is it you **feel** when you finish? Why does the experience leave you both shaken and exhilarated and compel you to do it again?

This is where writing about these sports helped me to understand something about myself. I really love to ski the steeps, so, in an essay about extreme skiing, I asked myself why this might be. I thought for a long time about exactly how I felt when I skied a very steep slope, and what it was I experienced afterwards. I loved the sense that I was delicately poised, even dancing, between two great forces that were much larger than myself -- balanced between the great bulk of the mountain above and the inexorable tug of gravity below. I realized I loved the sense of focus that this delicate balance demanded. I then understood that I loved it so much because it left no room in my consciousness for all the static and petty anxieties of daily life to which I am prone. It dispelled all that. After I skied the steeps, even though I might have been frightened at times, I felt refreshed, cleansed and relaxed.

Likewise, skiing the trees. During a good run through the trees, I was reacting instinctively like a deer that was bounding through a forest. There was no time to think, only to react, as if I'd shifted from the flickering, anxiety-tinged images of daily consciousness to a deeper, primal circuitry.

I realized how important it was for me to break from daily life and touch on something instinctive and pure and simple. So here's a case where the creative process produced its own rewards. I progressed from simply **describing** these winter sports, to really **feeling** what it was that drew me to them. They finally yielded to me something that I hadn't known about myself.

A lot of my writing has to do with travel, with writing about remote places and people and my experiences there, which illustrates another aspect of my technique or creative process. The great problem is that I return from a journey, say, to Greenland, or West Africa, or Manchuria with notebooks and notebooks full of daily journal entries but little notion of what this trip was all about. I return home, and I have to ask myself, "What is the story here?"

Sometimes, the story is not easy to find. I often feel that in those notebooks I have a big basket of scraps of cloth in dozens of different shapes and colors, each one a different bit of my experience abroad. I spend weeks or months selecting and fitting and arranging those pieces of cloth until I can fit them together in a way that they form the recognizable pattern of a quilt. I select bits of experience and throw a lot of them out, and fit others together in the patterns that make a story.

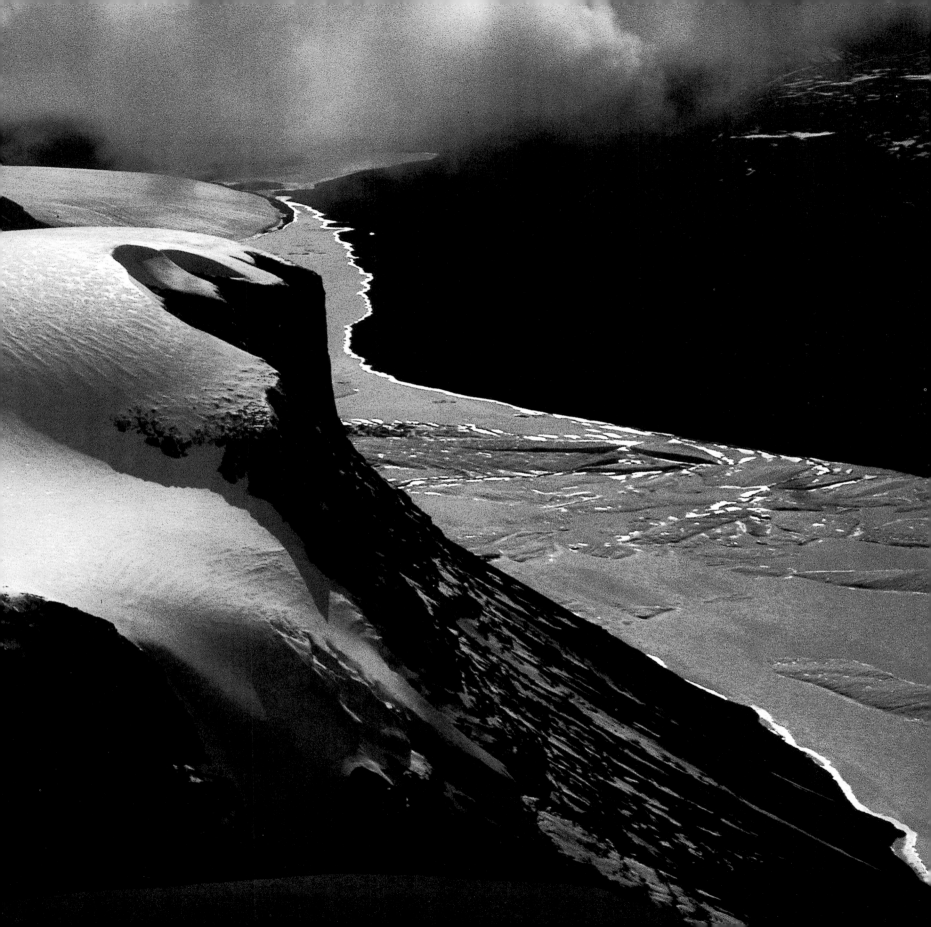

I suspect that anyone who is writing about his or her own experience, as I am in these travel pieces, undergoes something of the same process -- the teasing out of the story, or the meaning, that underlies the many experiences. On the one hand, I believe that what we experience has no meaning -- that events don't really mean anything at all as they occur. It's only in retrospect, in remembering those events, that we give them meaning. Our memories are the great editors. They dispense with what's superfluous and select other bits of experience that they load up with significance. Memory has the great benefit of hindsight to determine what's significant. They arrange these bits of experience into a certain shape to make a story. This is how our memories help us understand our past, and thus ourselves -- by making the past into a story.

What I've found is that the further something is in the past, the easier it is to write about -- or rather, the easier it is to find the story. I run up against this constantly in my own writing. I like best to write about something that happened years ago, but usually that's not the case. I'm often trying to find the meaning or the story in a whole sequence of events that occurred only a few weeks earlier, or sometimes a few months, and occasionally a few years, and the story is not always obvious. This is where I'm constantly saying to myself, "Okay, here are the raw events -- these notebooks, or these memories -- but what **really** transacted here?"

One technique -- a very simple technique -- I've found particularly helpful is to go run up a mountain. Any kind of strenuous, repetitive exercise will do it. The exercise becomes meditative and taxing at the same time. I let the thoughts about whatever I'm working on simmer as I strain upward, as if they're percolating slowly at the bottom of my mind. What happens is that I find that the superfluous details filter out leaving me only with what's important. When I'm straining that hard, I find I can only hold one or two thoughts in mind at once, and that they are somehow the "key" thoughts to whatever it is I'm working on. I like to think that in this stressed, panting, oxygen-deprived state, I can only hold onto thoughts that are significant.

Much of what I do in this creative process is throw things out. When I return from a journey abroad, I'll have somewhere between one and six months worth of notebooks and experiences. These end up in a story that takes at most a few hours to read. This is precisely what our memories do -- filter out enormous quantities of detail that they judge to be superfluous, and heighten the significance of the details that remain, in order to create meaning.

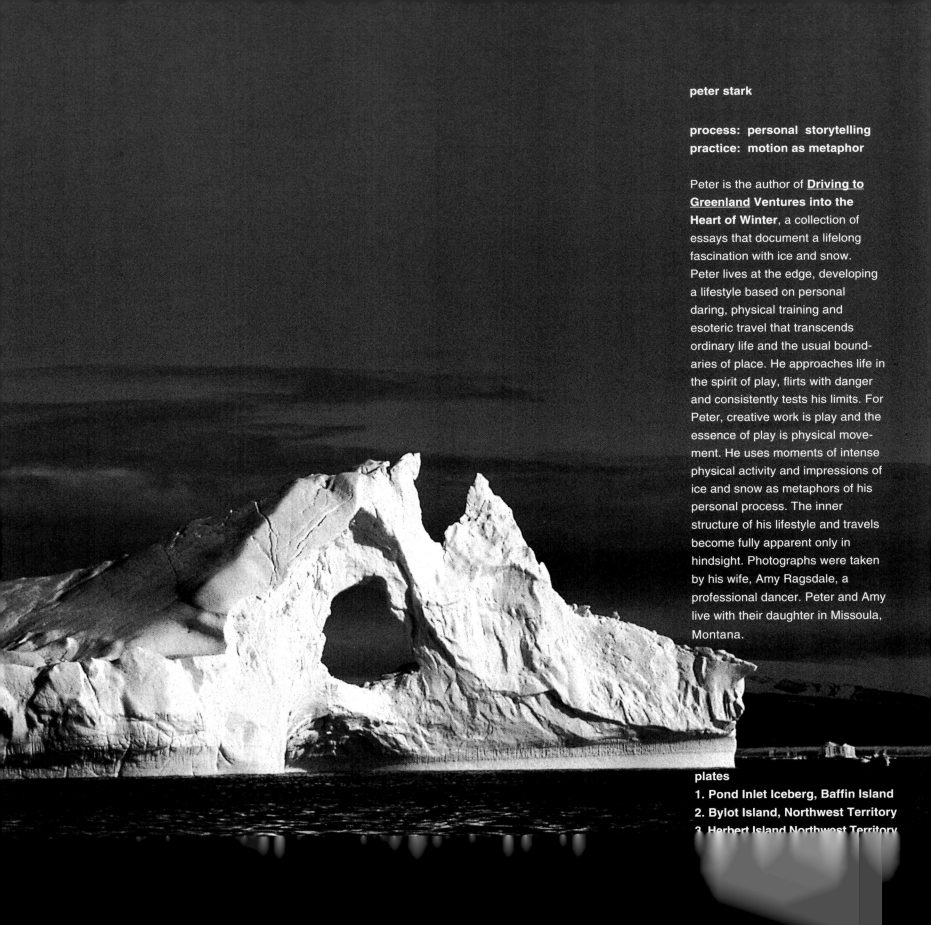

peter stark

process: personal storytelling
practice: motion as metaphor

Peter is the author of **<u>Driving to
Greenland</u> Ventures into the
Heart of Winter**, a collection of
essays that document a lifelong
fascination with ice and snow.
Peter lives at the edge, developing
a lifestyle based on personal
daring, physical training and
esoteric travel that transcends
ordinary life and the usual bound-
aries of place. He approaches life in
the spirit of play, flirts with danger
and consistently tests his limits. For
Peter, creative work is play and the
essence of play is physical move-
ment. He uses moments of intense
physical activity and impressions of
ice and snow as metaphors of his
personal process. The inner
structure of his lifestyle and travels
become fully apparent only in
hindsight. Photographs were taken
by his wife, Amy Ragsdale, a
professional dancer. Peter and Amy
live with their daughter in Missoula,
Montana.

plates
1. Pond Inlet Iceberg, Baffin Island
2. Bylot Island, Northwest Territory
3. Herbert Island Northwest Territory

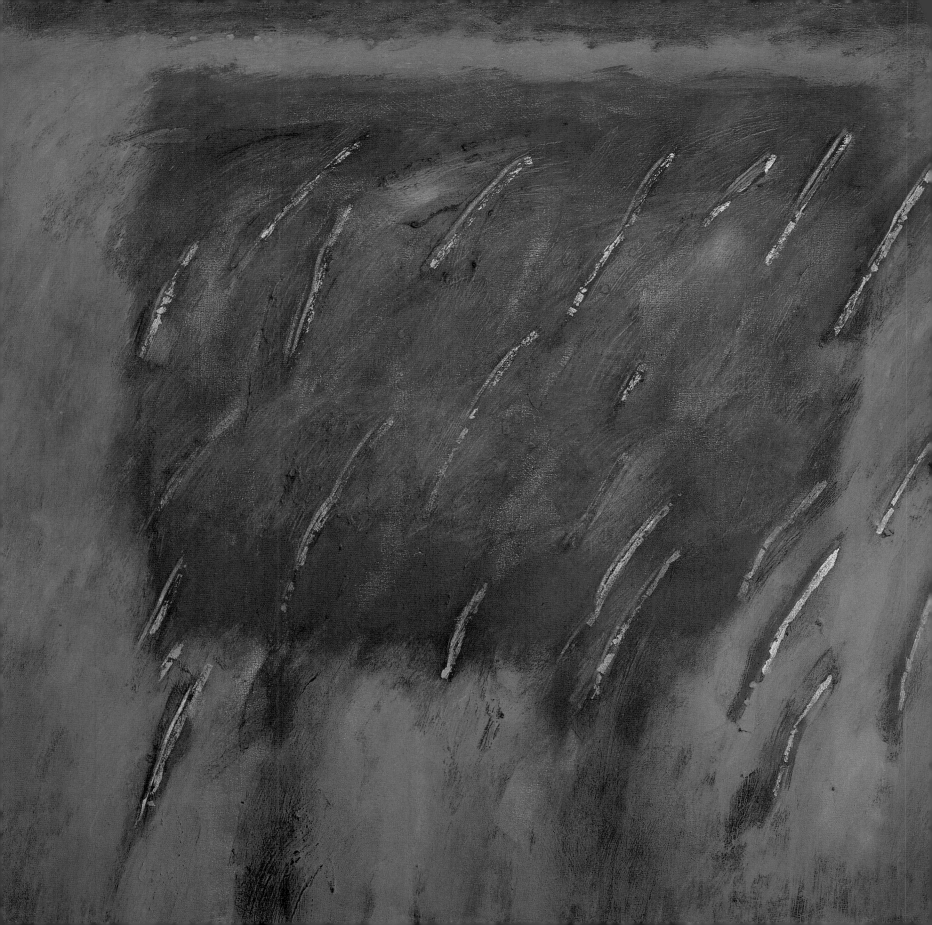

augustathomas

painting withsound

I don't think I chose to become a composer,
composing chose me.
It was sort of an inevitable outcome of
my curiosity, although I'm not sure
that is the right word. Composing is
my blood, guts, life and death.
I want that to come through.

My mind floats, progresses, drives, propels, shuttles between thoughts
very quickly. There is never a completely linear or obvious path between
ideas; everything is multi-dimensional. This condition is, of course,
reflected in my music, speech and writing that, while passionate, often
darts between perspectives, creating connections that may, in the end,
be clear only to me. Expressing my thoughts in a stream of conscious-
ness format seems like a good way to explain my work and myself.

Composing is my way of being. Music consistently propels me into the unknown and fantastic in a struggle between carefree, eager passion and enervating, self-critical doubt. The result is a music that is personal, direct, imaginative and honest. I care deeply that my music not be anonymous and generic or easily assimilated and just as easily dis- missed. I feel as if I have uncovered a musical language that has roots nurtured by ancient traditions and conventions and at the same time a vocabulary capable of ex- pressing and articulating contemporary experience. Music is universal and ageless. If I listen, it leads me toward the truth.

I must listen. It is my job not only to listen but to translate, communicate, and channel visceral impulses into the composition of music, a process that allows me to grow and develop, with each new piece of music becoming a journey of self-discovery. Remaining faithful to my deepest inner promptings and creative urges offers me the best opportunity to communicate with a willing listener, irrespective of their previous musical knowledge, professional training or background. The music I have found, or been given, seeks clarity of expression, immediacy, elegance, refinement, drama and passion. Every listener brings their own unique perspective, but honest music will find an honest listener for whom each encounter with music will be an opportunity for self-discovery.

For as long as I can remember, ever since I began composing as a small child, this infatuation with music has guided my daily existence. Growing up in a large family as the tenth of ten children, I was nurtured by an environment where love for the arts, passion for education and respect for creativity were essential. These conditions were not a result of material wealth, quite the contrary; but evolved from a belief in their intrinsic value. Formal training, age and experience have led to a more thoughtful, yet no less passion- ate engagement with musical elements. As I respond to primal musical impulses, I find that my convictions become more solid. The central and fundamental elements in my work, and the process that leads to and defines them, will never change. My emotions, the sense of urgency and joy of discovery remain intact; just as they were when I was six, perched under the piano listening to Bach, brimming with curiosity about how he made his two part inventions.

This is my life, my intimate agenda: On one hand, very simple: a large table, many pens, specific paper, a good light, an adjustable chair, hot tea, close friends, wonderful husband, quiet solitude, long hot baths, yogurt with fruit, green plants and fresh flowers, a book of twentieth century poetry, my CD collection... On the other hand: Early morning taxi to the airport, answering a fax on the flight, turbulence, correcting my student's work, approach to landing, lost baggage, late to rehearsal, two interviews, meeting with conductor, new hotel, answering three calls, make four Xerox copies, concert time, early flight back to teach, no lunch, two committee meetings, one load of laundry, negotiate contract, call for airline reservations, flat tire, birthday gift for family, write three letters. Balance is an art.

I am a vegetarian. Drinking many mugs of tea is part of my daily ritual. I never eat before two in the afternoon, preferring to focus completely on my work and always losing track of time. Later, I break from the score and spend several hours answering phone calls, faxes and mail as well as doing errands. Frequently, after a moderate meal, usually eaten at my desk while gazing at my score, I will go back to my work until midnight. This pattern is the ceremony that allows my mind to breathe freely.

Everything is a manifestation of that which is, simply is. Buddhism forms the basis of my life. I believe that music exists and it is my job to work hard, even suffer at times, to bring a small piece of music into focus. Music writes me, I do not write it. It is essential for me to be responsible to the score, to listen to it and to follow its inner path, never imposing myself upon it.

In third grade I took up the trumpet and continued to play for thirteen years, attending college as a trumpet major. In most cases, I was the only woman in the trumpet section as well as the brass section! Along with piano lessons and theory classes, this invaluable performance experience continues to nurture all my work.

There is scarcely a night when I am not awakened by a vivid and impassioned dance of ideas, images, reflections. When a symphony is bursting in my ear, mind, dreams and heart, I cannot escape it. In fact, this is my life, my work.

augusta thomas

**process: composing music
practice: discovering the
　　　labyrinth**

Augusta's agenda is contemporary
classical music that is abstract
rather than narrative. It takes us
into completely uncharted territory
and does not provide the reassur-
ance of hummable melodies or
orderly rhythms. Instead, the
dreamlike, seductive music paints
intricate images in the minds-eye
of a listener, investigating per-
sonal melodic, rhythmic and
harmonic landscapes. It is as if her
music were a three dimensional
form, a painting or puzzle, where
all the pieces intersect sympatheti-
cally. Augusta's lifestyle is a
perpetual surprise, in continual
motion, and requires a delicate
balance between freedom and
discipline. Recent projects include
Words of the Sea; **Ligeia,** a
chamber-opera; **5 Haiku**, a piano
concerto; and **Spirit Musings,** for
violin and orchestra. Augusta is
married to a conductor and lives in
Rochester, New York, where she
teaches music composition at the
Eastman School of Music.

plates
1. Blue, 1995, mixed media on
canvas, 36"x36", Cristina Lazar
2. Time 3, 1993, mixed media on
canvas, 42"x42", Cristina Lazar
3. Time 5, 1995, acrylic on
canvas, 48"x64", Cristina Lazar

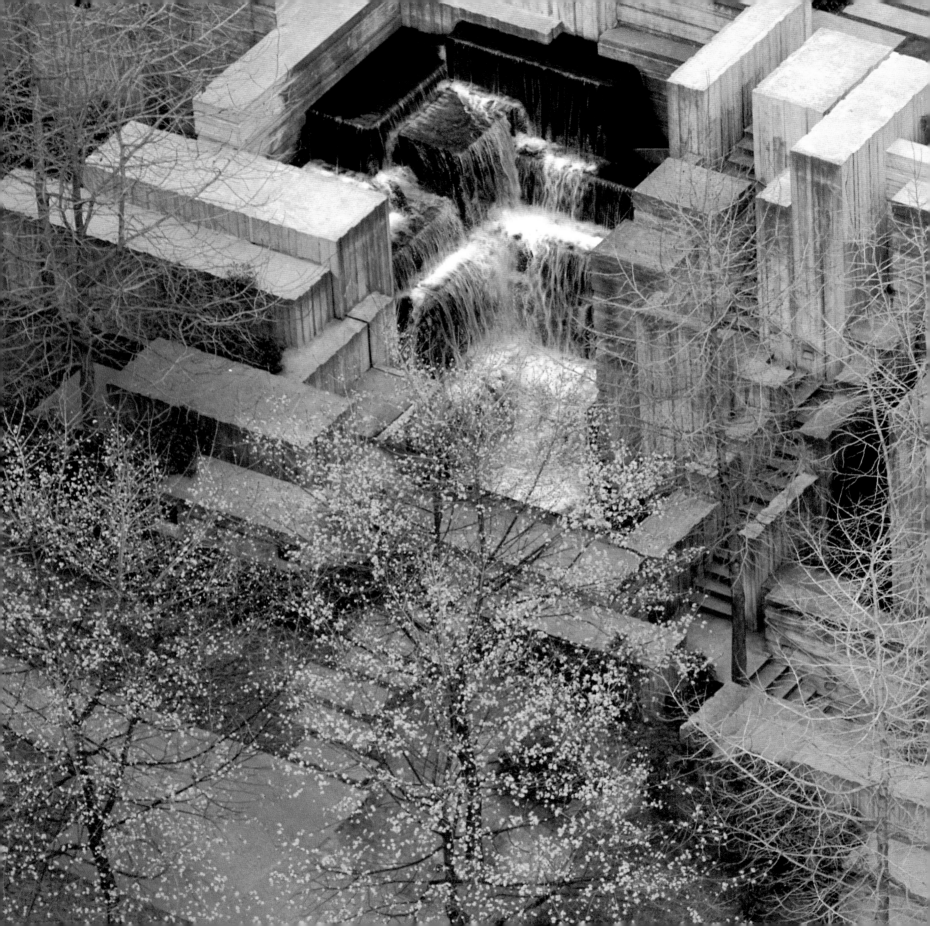

angela **danadjieva**

envisioning the **future**

there is a movement
in America
to make our cities
more liveable.
People are the city.

Time is of the essence.

As a planner, architect and urban designer, projects now on my drawing board take many years to complete. The buildings and landscapes I am currently designing will endure for many years after construction; so I have to be visionary, as well as courageous and creative, to figure out what we will need for our urban environment in the twenty first century.

The creative process is my passionate lifetime preoccupation. Since childhood, I have been obsessed with the pain and the pleasure of the creative process: pain, because I know that every project could have been better; pleasure, because striving for perfection forces me to extend myself and become more innovative. I love the excitement of breakthrough, the test of moving into unexplored territory. The greater the challenge, the greater my effort.

In nature, there is constant change and renewal. I see in nature the world's greatest designer and invite her healing powers and inspiration into all my work. Nature's magic permeates all my designs. I am inspired by natural materials- wood, stone, water and plants. My challenge is to create a deeper sensitivity to nature through association, in such a way that people will come to appreciate nature more. I am trying to build an urban environment with forms and materials that reach people emotionally, that will excite and challenge them. For this reason, I use asymmetrical forms that evoke a sense of motion, and water that explores movement and sound. Movement is life.

Accepting rejection is part of the process. My most innovative designs challenge present values and need more time before they are accepted. The design of the entertainment center, "Future Park", for Indianapolis is an example. The building design hints at the excitement of the high tech "virtual reality" entertainment activities that will be contained within it. Architectural form is defined by bent trusses covered in glass that project toward the sky, in an effort to incorporate a sense of cosmic awareness into the buildings overall character. It is inspired by Indiana limestone geodes and expresses the shape and character of a crystal. At the same time, the building incorporates natural elements of Indiana tradition with a solid limestone base. Sunlight produces a shifting spectrum of reflections that constantly changes the buildings image. At night, moving lazer beams directed through the glass toward the sky, are seen as if they were a kaleidescope. This project illustrates a breakthrough from static to dynamic imagery in architecture.

I need inner strength to do what I do. It takes time and commitment, but I have recieved a great deal of public support. Acting as a doctor to heal the urban environment, I redesign polluted freeway canyons, concrete flood walls, bridges and uninviting urban strips, transforming them into open space, parks, fountains, theatres and exhibit halls. In this way, I share myself with the environmental needs of many people.

The means to the end are illusive, the sources for inspiration infinite. When we contemplate the imponderable, and rejoice in participation with nature rather than conquest, creative efforts become a service to others.

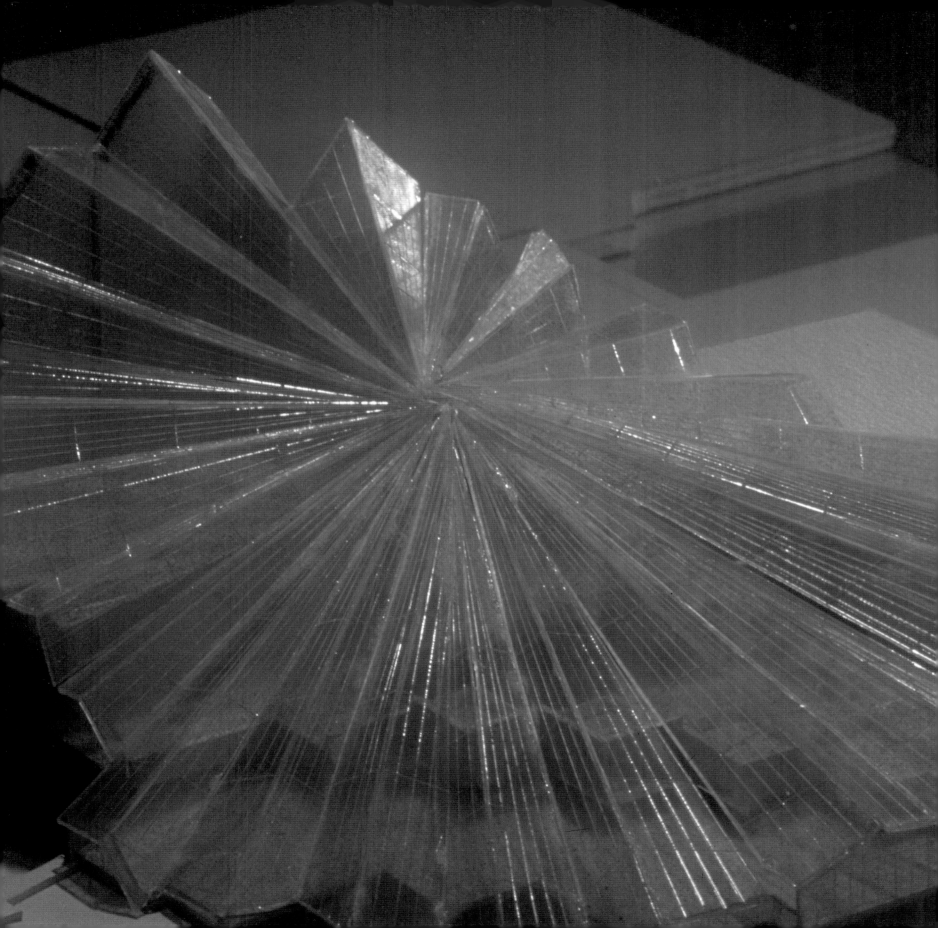

angela danadjieva

process: urban design
practice: collaboration

Angela grew up in Bulgaria, began
her career as a film set designer,
came to the USA and eventually
founded the multi-disciplinary
design firm of Danadjieva &
Koenig Associates that consists of
planners, architects, urban
designers, landscape architects
and interior designers. Due to the
large size of her projects, most of
her work involves close collabora-
tion with others. How do these
collaborations procede? Through
conversations, support, criticism,
resonnance, and opposition;
collaborators join together and
respond to each other in a dance
of mutual awareness. The various
designers each bring strengths
and weaknesses to the creative
process, providing both inspiration
and challenge to each other.
Angela has learned to tune in to
this myriad of voices that are a part
of every project, including its
ultimate users. Angela lives and
works in Tiburon, California, but
travels extensively to projects
around the world.

plates
1. Freeway Park Canyon, median
strip, Seattle, Washington, 1978
2. Theatre, Future Park, project
for Indianapolis, Indiana, 1994
**3. Washington Convention and
Trade Center,** ceiling detail,
Seattle, Washington, 1988

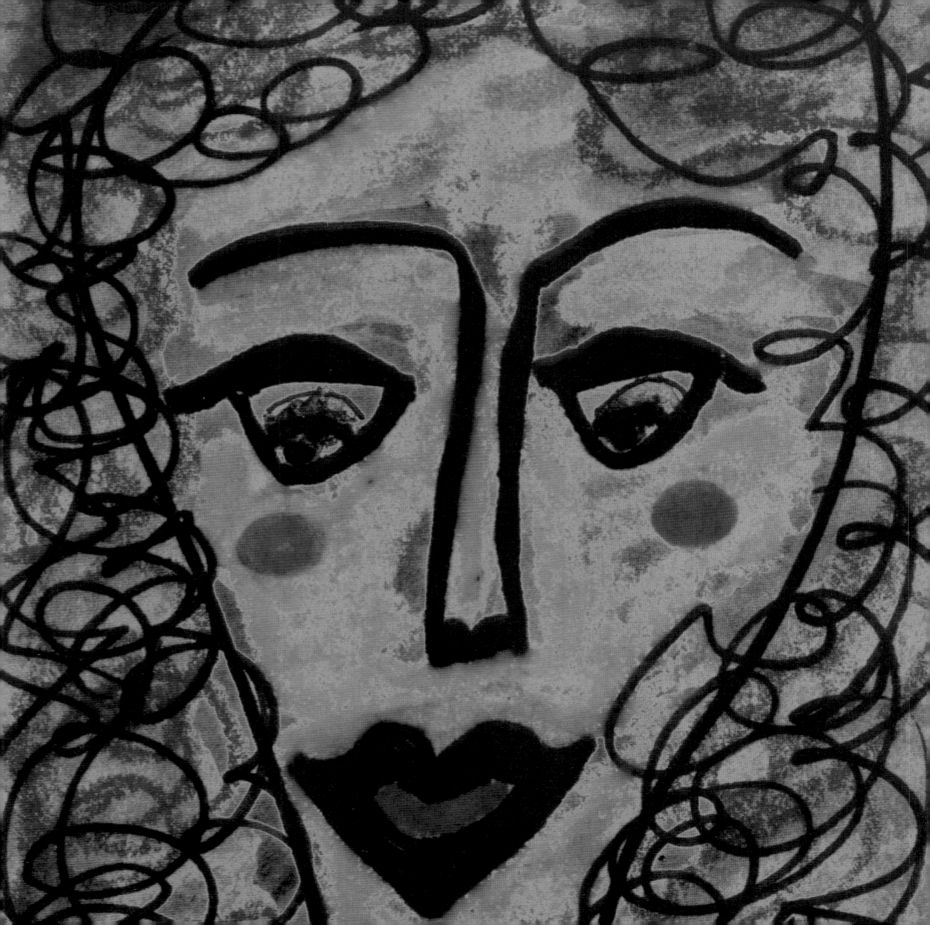

linda**aroyan**

redesigning a**life**

*building an artwork
that is my life for
my most important
artwork is
life itself*

It was august 1987. I was forty-eight years old and coming to
the realization that life was not going according to plan. My
kids were in their mid twenties and I had spent the last decade
trying to retrieve them from the abyss of drugs into which they
had fallen in their early teens. I was exhausted, devastated,
humiliated, ashamed. I have never felt so powerless and
afraid. I began to understand that if I didn't find a way to get
the focus off my kids and onto my own life, I would not survive.

And so I began a journey....

...a spiritual journey, a creative journey of self-discovery that has led me into a life which is quite amazing and wonderful, a life I could not possibly imagine from where I stood eight years ago. It has been filled with unexpected twists, new friends, new interests, joy and sorrow. I have made a commitment to grow, expand, be aware, feel my feelings, explore and not run away from challenge and difficulty. I have a commitment to do the best I can and let go of the outcome. I do this work for myself and share as much as I can with others who are also seeking new ways of being.

Several practices help me stay present with my unfolding life, help me remember that my life is constantly being created, and changing moment by moment. I am coming to the conclusion that awareness is the most important thing: awareness, acceptance of what is, and kindness to myself and others. My practices help me know and express myself. They have become part of me and part of my life. Sometimes I forget and think I do a practice because it has some intrinsic value. For example, I practice Zazen or Zen meditation because it helps me to be quiet and listen to myself, underneath words and ideas. I do not practice Zazen because I am interested in being a Zen Buddhist, but because I am a listener, a listener to the voice that is too quiet for me to hear in the rush of everyday life. Buddhism is a container for the desperation and isolation I used to feel. I sit everyday at home, and several times a week with friends, but the main thing is just to sit. Having a regular meditation practice makes life flow more smoothly and when things come apart, I am more likely to make decisions that are in my own best interest. Life and practice are becoming seamless.

Another practice I do is writing practice. Sometimes I forget what I am doing there too and believe I am writing to become a "writer." My intention is to write as a way to know myself, to reveal myself to myself, to allow things to become conscious. If I think of myself as a writer, I think I should be writing something meaningful or special, instead of just writing as a way of discovery. These are slippery places, these places where creativity floats between allowing and controlling, between expressing my deeper, truer self and expressing my press release; what I want you to see and think about me or what I see and think about myself. Creativity demands deep humility, the courage to go beyond the fear of being wrong. Creativity demands that we give up the need to look good, at all cost. It costs too much.

What is it you plan to do with your wild and precious life?

Painting is a tool used to express myself. I have no formal training as an artist, and again, if I begin to think "oh, I am an artist." I get confused about what I am doing. I had not painted since I was a child until a few years ago. As part of my commitment to explore creativity, especially things I was afraid of, I signed up for an eight week workshop at the Painting Experience. It was the perfect place to begin. It felt like being back in nursery school, before I knew about good art and bad art, before I succumbed to being a good girl instead of an explorer. The whole idea was to use painting as a tool of self-exploration and approach painting as an experience rather than making a painting. In the center of the room was a long table with pots of tempera in every imaginable color and three different brush sizes. We tacked our paper to the walls and walked back and forth between the paints and paper, not thinking too much, just allowing ourselves to paint and discover what images wanted to appear. I continue to paint, not because I am good, but because it thrills me.

Recently, I have been working on a series of small paintings using chalk, pastels and oilbar together with watercolors. For the first time, I have combined painting and writing. I started these small paintings in December, two months after my daughter disappeared. As the months go by, it seems less and less likely that she is still alive. But we don't know and the not knowing is desolate. I began these paintings because I needed something to do, and then I realized that I wanted to gather words: some mine, some quotes from others, that I find encouraging, inspiring, humorous or that put life into a bigger perspective. I began writing these words around the edges.

Lately, I have been painting faces; women's faces. I think they are me, talking to myself, consoling, soothing, encouraging myself. I didn't realize it at the time, but these paintings are a part of my grieving process and also part of my healing. Most of the time I am unable to verbalize what my artwork is about, but I know that it is moving something within and it is not necessary for me to name it. The important thing is to keep doing it and trust the process.

As I write, I am struck by the way one thing has lead to another these past few years and how my life has changed. Creative energy flows freely when we are able, often out of sheer desperation, to put aside our perfectionism and become adventurous and wild again. When we are willing to share this journey with others by telling about our losses and fears and dreams, magic can happen. It is the experience of our shared humanity, our deep connectedness, that gives life meaning.

Decide to forgive yourself, don't wait until you deserve it

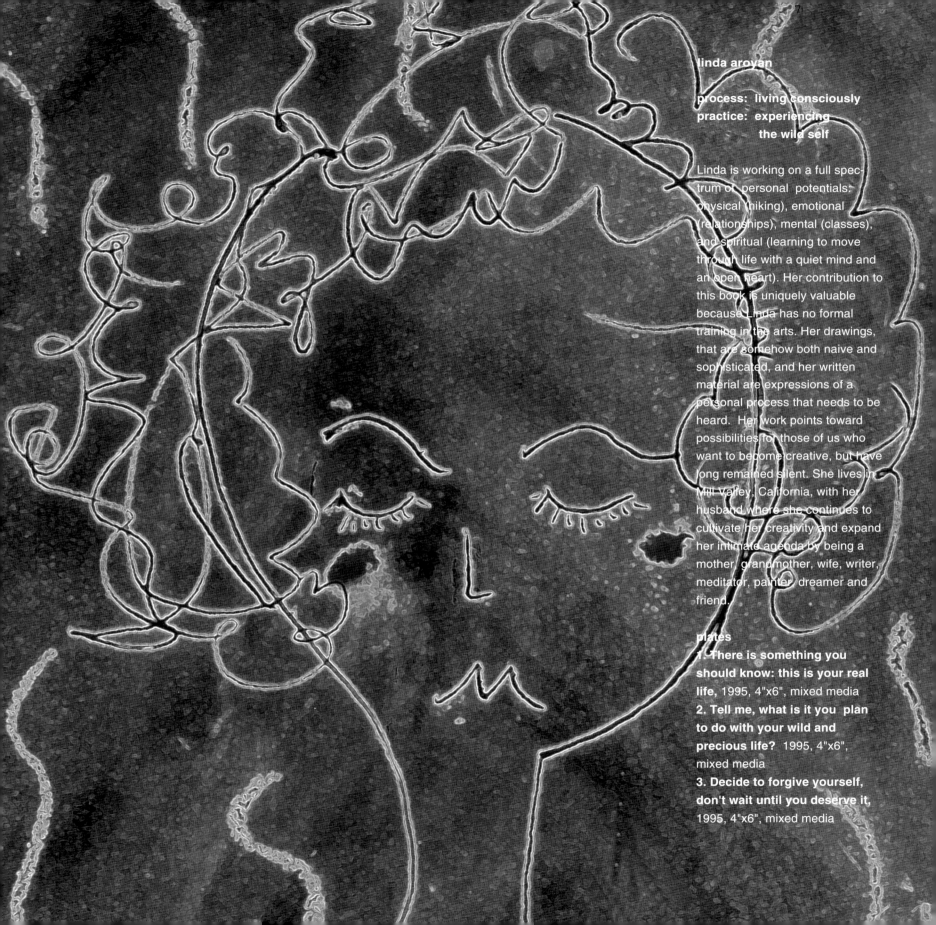

linda aroyan

process: living consciously
practice: experiencing
 the wild self

Linda is working on a full spec-
trum of personal potentials:
physical (hiking), emotional
(relationships), mental (classes),
and spiritual (learning to move
through life with a quiet mind and
an open heart). Her contribution to
this book is uniquely valuable
because Linda has no formal
training in the arts. Her drawings,
that are somehow both naive and
sophisticated, and her written
material are expressions of a
personal process that needs to be
heard. Her work points toward
possibilities for those of us who
want to become creative, but have
long remained silent. She lives in
Mill Valley, California, with her
husband where she continues to
cultivate her creativity and expand
her intimate agenda by being a
mother, grandmother, wife, writer,
meditator, painter, dreamer and
friend.

plates
1. There is something you
should know: this is your real
life, 1995, 4"x6", mixed media
2. Tell me, what is it you plan
to do with your wild and
precious life? 1995, 4"x6",
mixed media
3. Decide to forgive yourself,
don't wait until you deserve it,
1995, 4"x6", mixed media

Dreams stretch across the interface of consciousness and unconsciousness. They reveal infinite potential for the creative process, converting invisible energies into symbols perceptible to the conscious mind.

Dreaming is a process, a sensation in the body, an awareness in the mind that allows me to see life in symbolic terms.
jeremy taylor

My dreams and thoughts are aligned with the Sangre de Christo Range; the house and the cloister are one; a complete dreamtime, a continuing dance.
carol anthony

Dreamwork is a practice that keeps me present with my unfolding self. It centers me in a space where images originate and allows me to confront invisible energies on a daily basis.
barbara seidel

dreams symbolic

messages

jeremytaylor

dreaming as an art form

My most intimate, daily, meditative, creative practice is keeping as accurate and complete a record of my dream experiences as I can. For more than thirty years, I have scribbled words and sketched images, almost every day, trying to record and capture the feeling of each dream I have been able to recall, in an on-going effort to consciously understand them better.

Dreaming is
the gateway
to infinity
Carlos Castenada

My wife and I share a deep interest in dreams and the creative inspirations that regularly flow from them, and we tell each other our dreams every day, usually over breakfast. Over the years, we have both had occasion to express the thought that if we had not shared this secret window into one another's souls and psyches - we might not have been able to weather and survive the emotional storms of our more than thirty year marriage, anything like as well as we have...

My journal keeping practice has evolved over the years from buckram bound volumes of lined paper, to spiral bound volumes of recycled artist's sketch paper. The unlined pages remind me to draw as well as write. These days, I color the hasty sketches using broad tipped highlighting and layout pens. There is an archetypal resonance between color and emotion, and I find that taking the extra step of coloring the dream awakens and promotes deeper conscious understanding of confusing and subtle emotions.

For many years, I have covered each successive volume with collages of images collected from the ephemeral graphic printed media that fill our post-modern lives. One regular recurring element in making these collages is scattering pieces of a fiendishly difficult jigsaw puzzle that I purchased years ago for five cents from a frustrated puzzle maven at a flea market. Assembled, the puzzle would make a perfectly round mirror more than two feet across. I have incorporated the pieces of this mirror/puzzle into the collages on my journal covers as part of a continuing joke about the effort to understand the individual puzzles posed by each dream, and to acknowledge the inevitable implication that taken all together they reveal an even greater mystery, a mystery associated with recognizing the true self. One of my fantasies is that when I die, my whole life, including all my dreams, will flash before my eyes, and I will suddenly and finally "get it", experiencing an all-encompassing aha of understanding that is the symbolic equivalent of catching sight of my true face reflected in the dream jigsaw mirror, finally assembled.

More and more things find their way into this journalizing process: fugitive doodled pieces of paper, letters, clippings, notices, notes, maps, agendas from meetings, theater programs and ticket stubs, pressed flowers and leaves; things that would otherwise have been discarded. Now, they all end up sticking to the pages of my dream journals in an ever-expanding collage of the experience of my life. The poems and proto poems, the ideas for other creative projects, the emotional ramblings and political polemics, the notes from lectures and workshops, the responses to books and movies, and the musings on the deeper meanings and significance of things below the surface of appearance; they all arrive on the page first in this all-purpose, omnivorous dream journal.

Pink and Red Neon Meet at the Corner

This seemingly inconsequential dream fragment, consisting of a snap shot of two glowing tubes, highlighting the meeting place of walls and ceiling in the room I was in, is a good illustration of how drawing a dream can clarify dream content, for I suddenly realize that this dream flash is a symbolic statement of a practical solution to a problem I am having rewriting the second draft of my most recent book, <u>The Living Labyrinth - Universal Themes in Myths and Dreams.</u>

Prior to this dream, I had been struggling to rewrite the first chapter that lays out the basic premise of the book. What the visual record of the dream caused me to realize was that I was having all this trouble rewriting the first chapter because it was actually two chapters, one red and one pink; closely related colors that might be mistaken for one another close-up, but different enough to be distinguished at a distance. And I saw, at a practical level, what I needed to do was read through my manuscript of the first chapter and physcially mark the separate sentences and paragraphs as either pink or red, and then divide the ideas into two separate chapters. It worked like a charm, transforming what had been a burdensome word problem into an easily solved color distinction activity. It was clearly the activation of the visual limbic system, brought about through the act of drawing the dream that focused my conscious attention on the radically different and marvelously efficient color coding solution to the rewrite problem.

Later, I often copy more developed and refined versions into other volumes, reserved for specific purposes, but it all starts here. The resulting layers of collage that build up on these pages add texture and flavor and resonance and depth to the growing understanding of what my life is really all about.

Over the years, the layers of meaning and signifigance revealed, particularly by the earliest dreams, has deepened and expanded. It is now possible for me to catch glimpses of the most fundamental and authentic aspects of my character and personality, and to understand more fully how they have shaped my life experience, and how they continue to give structure and meaning to my life and work. Looking at the oldest dreams from thirty years ago, like geological formations that reveal their inner strata and fault lines more and more clearly over time, I can now see the outlines of the basic questions, dramas, ideas, and images of my life. Rereading the dream record allows me to see just how these geological patterns repeat and evolve. This is who I really am, even though I didn't recognize it at the time. This is what my life is really all about, even though at times I had imagined it was something different...

The whole journal is color coded: the dream experiences are recorded in various colors and the waking life entries are either dark blue or black. I have cultivated the habit of giving the dream records short evocative titles when I record them. This allows me to go back over the dream memories and to look at them in sequence and begin to catch sight of the shape of the forest as a whole, instead of just the individual trees. Recurrent motifs, themes, seasonal rhythms, and evolving archetypal dramas in this way become more visible and conscious. The titles are picked with an eye to evoking the experience of the dream, rather than memorializing any particular insight into their multiple layers of meanings. That way, the dreams are always invited to go on giving their gifts of insight and creative inspiration each time they are revisited.

In the course of this ongoing meditation, I have come to see my life more and more in symbolic terms. I recognize the footprints of the larger, archetypal, divine energies in my waking and dreaming life with increasing regularity. As a writer and graphic artist, I find that journalizing practice is the best inoculation against writers block that I have ever discovered. Any effort to render the subtle and ineffable experience of the dream onto the page is doomed from the outset to compromise and failure, but it is out of these failures that the most interesting and satisfactory insights and creative expressions regularly arise.

Knowing beforehand that a blank, perfect pristine page will be defiled by an inadequate expression has not stopped me in a good long time, in large measure because the daily practice of recording and rendering dream experiences keeps the expressive muscles active, and overcomes the chilling perfectionism that is at the root of all blocks to free flowing creative expression. I will never get the dream down on the page with the same force and subtlety with which I first experienced it, but the continuing effort to do so is constantly energizing.

Keeping regular track of my own and other peoples' dreams demonstrates what inherently interesting, creative and generously energetic creatures we all are. The cosmos manifests in an endless dance of creation. When we are fully relaxed and deeply asleep, we reveal our divine origins and connections by creating whole universes every night. The symbolic language of this collective outpouring of creativity is as simple and clear as a blossoming wild flower, and as somber and complex as the struggle of a predator and prey. Each night, the truer meanings of our lives, the mythic dreams that are played out beneath the surface of waking appearance, but which determine the outcome of our waking effort, are played out to us in the form of enigmatic dreams.

The practice of sketching, drawing and coloring dream images fixes the dream experience in the conscious memeory more fully. Drawing enhances the likelyhood that even more of these initially hidden gifts of the dream will be recognized as time passes. Drawing a dream shifts the dreamer's cathexis to the visual limbic system. This nonverbal level of awareness often opens us to vivid and immediate "ahas" and insights that are more all-encompassing and intense than the purely verbal and conceptual insights that are usually generated by writing or talking about a dream. A similar broadening and deepening of the conscious encounter with the dream can also be achieved by embodying the dream, that is, by acting it out physically.

I have devoted my life to bringing the instinctive knowledge of this ancient universal language which we all share as part of our natural birthright as human beings, up to the surface of waking consciousness where it can be seen, understood, and transformed into creative expressions to share with others. We all share an unconscious understanding of this universal language of symbol and metaphor as part of our natural birthright as human beings. When we pay more attention to dreams, we discover a deep, common humanity that binds us together, even across barriers of seeming uniqueness and separation that so often estranges us from each other. When we turn our attention to our dreams, the archetypal creative impulse that fuels our deepest desires and aspirations comes more and more within our conscious grasp and ability to express. In the dreaming communion of the night, we are renewed and made whole again.

jeremy taylor

**process: accessing the unconscious directly
practice: journalizing**

Jeremy's ongoing intimate practice is dreamwork. Through dreaming, an activity common to us all, he hopes to activate a more compassionate concern for others as well as a deeper understanding of the self. He trains and works with individuals in small group settings where people share dreams, learn specific dream-work techniques and acquire an understanding of dream symbolism. As a teacher and dreamgroup facilatator, Jeremy shares with us his methodology for recording dreams and explains why narrative text in conjunction with drawings of a dream can facilitate and clarifiy meaning. Titles are also a signigificant part of this process. Jeremy is a Unitarian minister as well as a free lance teacher, counselor, and writer who lives in San Rafael, California.

plates
1. **Dream Journal Cover, Volume 57,** 1994, collage detail
2. **Pink and Red Neon Meet at the Corner,** 1995, pencil and marker
3. **Buffalo Hide Chronical of the Taming of the Horse: Plains Indian Art,** pen, pencil and magic markers
4. **Diagram of the Slender Hand Holding a Transparent Cube,** 1994, pen, pencil and magic markers

IL
MAPPAMONDO
RIDOTTO IN QUADRO.

[The two columns of body text are heavily faded and largely illegible.]

carolanthony

respectingsilence

Where a painting comes from
is where I am. In me,
at that moment
and without time

I live in a cloister that defines and surrounds an ancient space, carefully chosen, between four pinon trees and overlooking a view of the Sangre de Christo Range. Everything is aligned to that particular mountain view and viewpoint of spirit. Here, my dreams and thoughts are written, drawn and grounded. I become still and listen. This cloistered garden is my version and vision of remembered courtyards and atriums, a place where light and shadows join in a continuing dance. Energy and mystery play an integral part here...

I need now to be a part of
the Western landscape
its wild and softness
its magic and sacred.

I want to feel the dust
of the ancient ones,
their big prairies
and wide skies
their sages and spirits.

Through symbols of
mountains and arroyos
pinon and meadow,
hidden roads and trails,
I try to disturb and embrace
some of the inner mysteries
of solace and reverie,
earth and stone.

Each work is gently mined
from daily pilgrimages
into the texture and shadow
of land and light around me.

My paintings are about
exits and entrances,
beginnings and endings,
forgotten renewals
and retrieved promises.

Each hour kept secrets
in old gardens and columned rooms
of remembered childhoods
of dreamtime.

My paintings are ancient
moments and portraits
of other places and rituals
gathered, embraced and spared.
All are attempts at
solutions and celebrations
of our continual need
to hold and protect
the country within us
and know that we are all one.

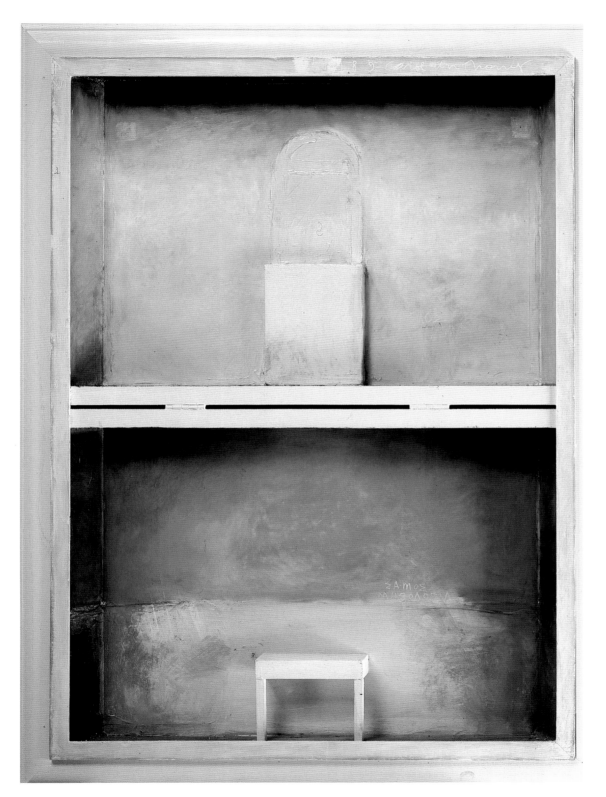

carol anthony

process: speaking from the heart
practice: solitude and retreat

Carol speaks eloquently through paintings and prints that create atmospheric light and shadow, evoking a sense of mystery. Carol's practices of solitude and retreat are not isolating but thoughtful and highly productuve. Carol says: "The lonlier and more melancholy the place, the more it compels me to enter". She moved to the New Mexico desert five years ago, to live alone and paint. Since this move to the Southwest, the northern New Mexico land-scape has become the focus of her work. The house and studio form a temenos or magic circle; a sacred space within which special events happen, dreams occur and inspiration arises. Her images seduce us, asking us to connect with our own solitude and the poetry of our personal environ-ments. Carol's ephemeral paint-ings and prints are worked and reworked in a manner that gives us a sense of the feelings that lie just beneath the surface.

plates
1. Ancient Page: Mappamondo,
1995, monotype, 12"x12", with Sante Fe Hand Graphics
2. Samos Sanctuary Room,
1989, box construction,
31"x29"x2"

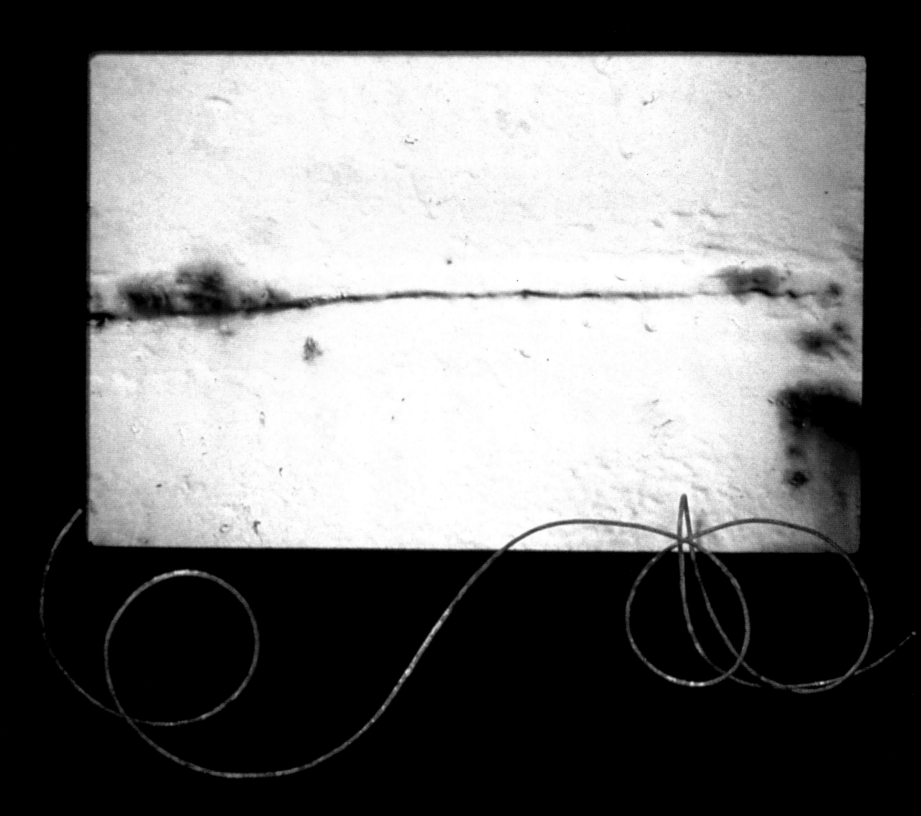

barbara seidel

paring down to essence

*walking by the sea, learning its rhythms
the tides and seasons, the cycle of life
how precious, how tentative
exploring the numinous energies of the sea
taking the time, making the commitment
to know a landscape in depth
with a silent mind and radical humility*

Some years ago I dreamed the following dream: We are off by ourselves on the beach of a small island, isolated from the world. A few of us are dark skinned. I am one of the those guiding others in esoteric knowledge. We use a text, but some of the pages are lost and I substitute a long string of ancient beads that stretch across the pages. On waking, I know it is the beads that tell the story.

It would be many years before I recognized the full significance of this dream. It was my first inkling of what was to become my own intimate agenda. The metaphor of the missing pages suggests that there will always be more to know and the substitution of the primitive beads for text suggests the efficacy of ancient wisdom as a path for me to follow. I believe that the dream foretold, at one level, my recent entry into the field of book design and publishing, and that the missing pages represent skills and information I would have to acquire. It is only recently that I have come to appreciate fully how a dream can become reality. As I learn to access my inner self through dreams, artwork and book design, I have come to believe that, with practice, many people can tap into their creativity in a similar fashion.

Today, the primary materials used in my creative process are deteriorating fragments: bleached bones, weathered wood, tattered fabric and, yes, ancient beads. Working with actual remnants from the past rather than art materials purchased from a store, I dwell on the fragility of life and seek ancient wisdom through lingering residues and found objects. The process is slow, but cumulative.

I have few answers and many questions. Not knowing where it will lead me, I experiment in various media: collage, photography, assemblage, hand papermaking, bookmaking and encaustic. I am trying to make the invisible visible through the creative process, knowing there is always more to know. The architecture of consciousness has become a compelling force underlying my life and work. My current focus is the intimate agenda, but I also create limited edition handmade books with small assemblaged sculptures or wall canvases that accompany them.

Additional motifs and juxtapositions which express my understanding of life and art are intimate things that are small, compact and quiet; accidental things that allow the unexpected to occur; murky things that have a vague, bleached or attenuated quality as they approach nothingness; simple things that are restrained but elegant; materials that are vulnerable to natural processes such as those weathered by the sun, wind, water. All these themes appear in the previously described dream.

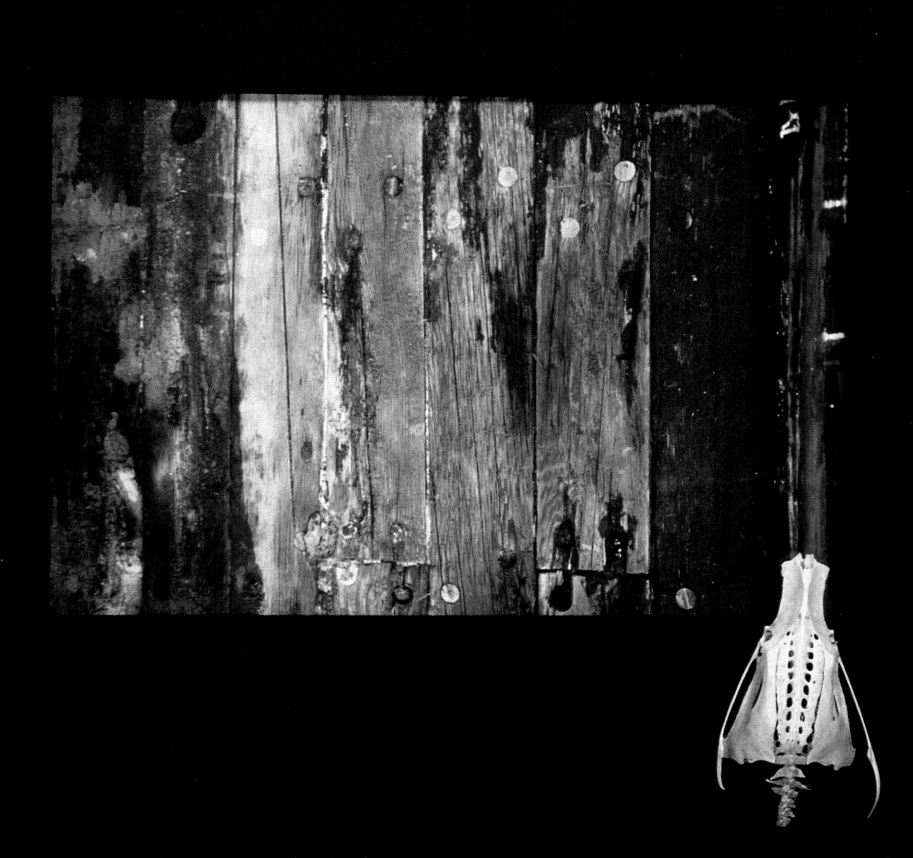

The series of assemblages, "Seamarks", is my way of seeing and feeling a landscape in depth. The photographs were taken after a storm, when I discovered a shipwreck while walking near Richardson Bay, California. Daily seawalks involve picking up debris from the ocean's edge, and some of these water-eroded scraps were combined with extremely close-up cibachromes of the disintegration that had occurred on the side of an ancient fishing boat. The resulting photo assemblages reflect the inexorable passage of time. They acknowledge natural processes, fragility, disintegration, impermanence and the idea that everything eventually fades away into nothingness.

As for my personal practices: I rise early and immediately go to my computer to record my previous night's dreams. It is helpful for my creative process to study and attune to the language of symbols that speaks through dreams. Although these symbols seemed obscure at first, years of practice make the interpretations somewhat easier. Beyond this, life is loosely organized. Minimal possessions and a lack of clutter lie at the core of my process. Recognizing the human capacity for conscious evolution, I try to stay present in the moment and let things evolve.

My environment is crucially important: views, space, light and shadow, the sounds of the creek, the wildflowers that surround my house. I know my house intimately, having gutted and remodeled it, room by room, over a ten year period. Architectural space sets the tone for everything that happens within. My home is simple, barefoot and casual. White walls, stone floors, several pieces of contemporary art, my own work in progress, a chunk of marble from a nearby quarry, a vase of flowers and that's it. I make a point of looking at and really seeing these things every day. With fewer objects, what's there becomes more important, more visible. Subtle sensory elements, like diffused light or a small amount of brilliant color, are more exposed and appreciated. This pristine, yet sensual environment is a prerequisite for all of my creative endeavors.

I am learning to tread lightly, while living a life that focuses on intrinsic values. I am in process, paring down to essentials, getting rid of all that is unnecessary, but without removing the poetry. I am only beginning. Dreams and creative work are my path.

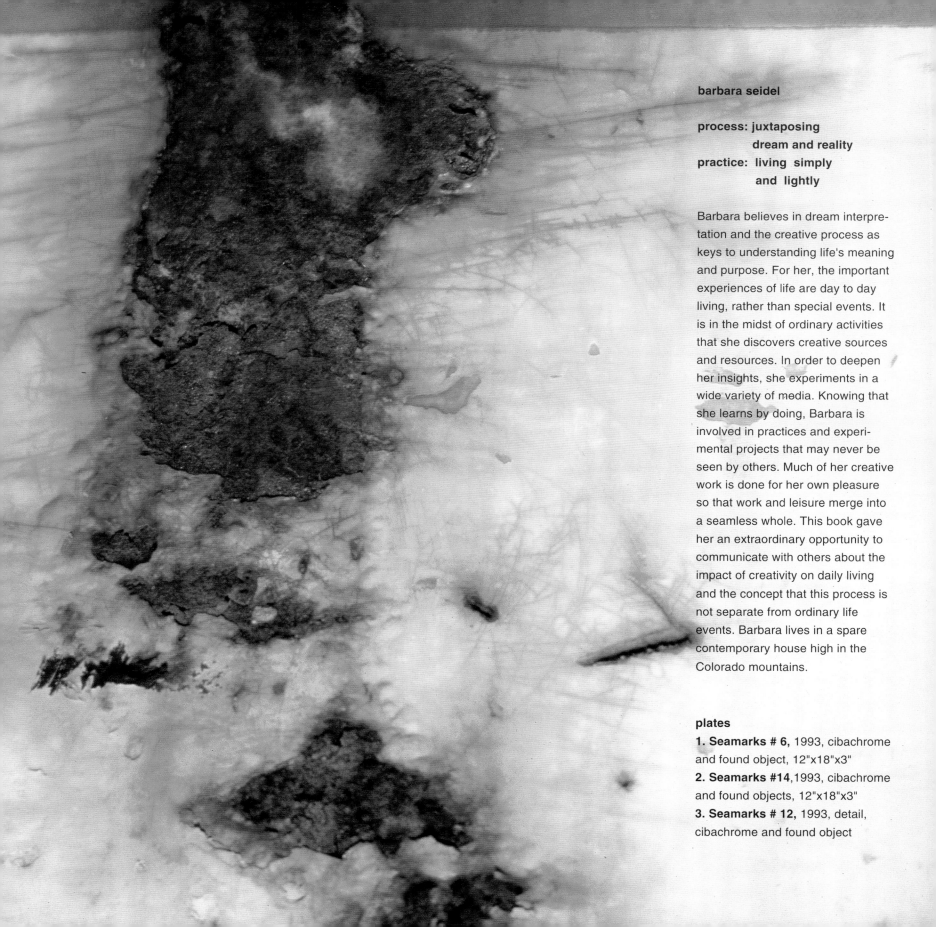

barbara seidel

**process: juxtaposing
dream and reality
practice: living simply
and lightly**

Barbara believes in dream interpre-
tation and the creative process as
keys to understanding life's meaning
and purpose. For her, the important
experiences of life are day to day
living, rather than special events. It
is in the midst of ordinary activities
that she discovers creative sources
and resources. In order to deepen
her insights, she experiments in a
wide variety of media. Knowing that
she learns by doing, Barbara is
involved in practices and experi-
mental projects that may never be
seen by others. Much of her creative
work is done for her own pleasure
so that work and leisure merge into
a seamless whole. This book gave
her an extraordinary opportunity to
communicate with others about the
impact of creativity on daily living
and the concept that this process is
not separate from ordinary life
events. Barbara lives in a spare
contemporary house high in the
Colorado mountains.

plates
1. Seamarks # 6, 1993, cibachrome
and found object, 12"x18"x3"
2. Seamarks #14, 1993, cibachrome
and found objects, 12"x18"x3"
3. Seamarks # 12, 1993, detail,
cibachrome and found object

Through an alchemical process, art provides us with a reflective language of form, word and gesture that is a direct expression of life itself. As our agenda unfolds, it manifests our own uniquely personal style.

My way of tapping into creative energy is through exercise, meditation, dreamwork, and enjoying the simple pleasures of life.
morley clark

The secret ingredient that gives a piece magic is love.
michael emmons

An answer, if it exists, is not waiting for me at the end of the process. It is wrapped around and tangled into the work itself, into the layers and strata that a viewer must physically move.
emil lukas

My greatest fear in exposing myself through my work is that what will be revealed is a dark and dangerous secret; possibly the explosive power of creative energy itself.
rebecca didomenico

changealchemy & transformation

8-10-95

morleyclark

looking between the lines

I am intrigued by the space between the lines and the thought that space holds things that are not yet formed

I am a witness to change.

I live in Northern California where the seasons express their cycles dramatically. Weather systems move in and out over the mountains. In fall, the leaves begin a subtle evolution in color, eventually leaving bare the ancient gnarled and sculpted oaks— with stripped limbs and twigs creating a lacy light against the profile of bark. It is always mysterious and miraculous for me to see how nature's energies coalesce into recognizeable forms that are perpetually the same, yet, always different.

I am always looking, sensing, exploring my responses to the environment in order to discover and express a personal truth. I have kept a journal for many years and continually explore the space between consciousness and my interior world as I record dreams, thoughts about nature, art and trips I have taken. These writings form a continuum of expression; a vital basis for my artwork. Each day begins by remembering the previous night's dreams. I use small handmade sketch books for drawing in, as soon as I wake. Silence is essential. Since moving to the country, life is very simple. There is a spare reductive quality in how I live; having only what I use, using all that I have. This simplicity and my daily rituals of walking, swimming and journal writing are a way of clearing my physical and emotional space, of preparing an easier access to my art. When the work is successful, this quiet and contemplative existence makes the invisible more visible.

My studio is set in a wooded area with northern light flooding in through a bank of slanted windows. On a counter lies a collection of stones, twigs, leaves, pods and peelings of bark found over the years on walks near the house. These bits and pieces serve as talismans; their color, form and markings connecting me to a particular moment in time and serve as metaphors for the energies that created them.

My drawings are an effort to reconcile myself with nature. The act of drawing initiates an intimate dialogue with unconscious aspects of myself. Marks and subsequent layers of pastel are placed as if they were veils of time. Although my images do not derive directly from dreams, my dreams offer an interpretive response to the conscious world, and, as such, may inspire a particular piece or suggest a title.

Drawings begin with ink, sometimes graphite. The initial plane is a grid with lines that are woven in and out of the grid form. A field of light emerges gradually. After the initial ink marks-- pastel, graphite, and charcoal are woven into the image. I often erase an image extensively, so that there is a reductive quality to the work. Kneaded erasers become drawing tools. New layers are added. Veils of line and pastel, sheer and transparent, give a viewer access to the history of the drawing. My process is both reflection and metaphor for the transformative qualities within nature and ourselves.

9-5-95

morley clark

process: drawing light
 and space
practice: responding
 to nature

Morley is an abstract painter
currently working in ink and pastel
on paper. A delicate touch and
meditative processes are keys to
the content of drawings that take
us into a landscape created by
marks and traces of gestures.
Images emerge slowly over time,
expressing Morley's feelings about
nature and the inevitability of
transformation and change. There
is a certain randomness to her
work and, at the same time, a
clear sense of order. Morley's
personal style in life and art is
never static, but an ever-changing
balance that is continuously and
consciously adjusted. Her
drawings walk a fine line between
control and just letting things
happen. Morley and her husband
live in a remote rural area of
Northern California.

plates
1. White Shadows, 1995,
ink, pastel, graphite, 14"x15"
2. Untitled 9-5-95, 1995,
ink, graphite, pastel, 14"x11"

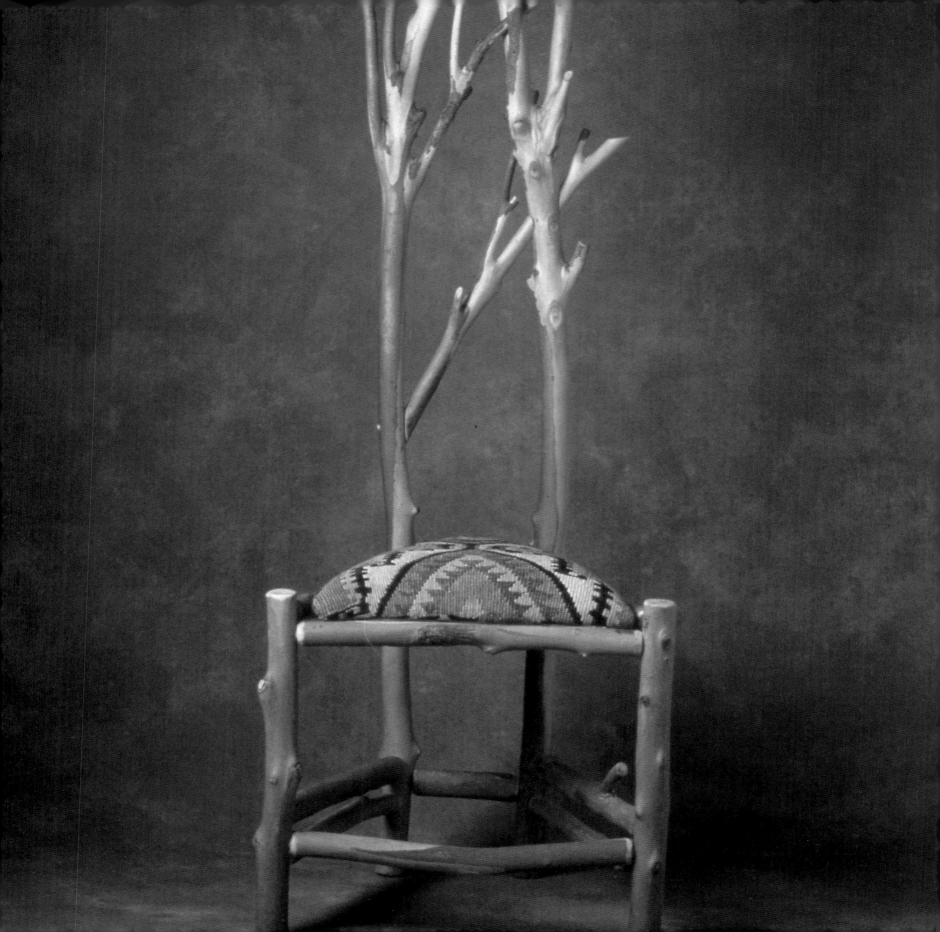

michaelemmons

and speaking of love

I draw the curtain
and turn on the light,
that's all.
Angels dance there
even in the dark.

I once read a quote that said: "Writing about art is like dancing about architecture. " I make furniture from eucalyptus branches and saplings, often incorporating river stones into the design. I also work with found objects and cast off junk to create mixed media sculpture. So I work with both organic and inorganic materials. Both speak eloquently of the creative process.

I will begin this dance by writing about my experience with three pieces that I recently completed. I was particularly pleased with the way these three chairs turned out. So, I started to examine my experience with the process to catch a glimpse of the secret ingredient that gives a piece magic. I love what I do, so I know that love is integral to the process, and it goes into every piece. But what is the thing that makes one piece stand out above the others— what is it that makes a piece really shine?

There are times when I am aware of a subtle energy that comes through into the work I am doing. The piece seems to slipstream into formation. In these moments, I feel that I am only a tool. The piece is building itself. One part of the form suggests another, and everything moves effortlessly toward completion. When this river is running, my hands seem to hear secret voices and translate those urgings into a manifestation of what lays unassembled on my workbench. It happens without effort. And all I need to do is be there — a tool waiting for the mystery to use it.

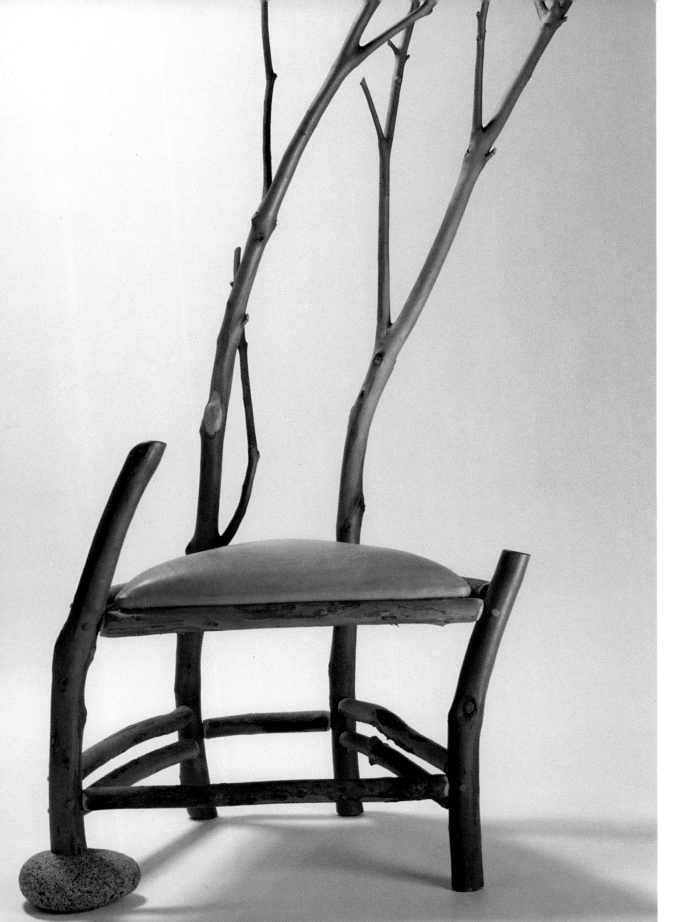

michael emmons

process: working with wood
and stone
practice: love, joy and magic

Michael lives in Big Sur, California, high on the cliffs overlooking the Pacific ocean where he works under the studio name of Bare Bones. He plays with various materials that he finds on the beaches and in the forests of this exquisite coastal sanctuary. He embodies his process by exploring the relationship between himself and the physcial environment, reaffirming daily the connection between man and nature. Found forms, textures and irregularities in stone and wood comprise the basic theme of his sculpture and chairs. Michael speaks of ecstatic feelings that sometimes well up within him, during the creative process. With special pieces, there is a transformation that occurs, similar to falling in love. It is this magic that lifts Michael out of the ordinary and reminds the rest of us not to forget our own potential for ecstacy.

plates

1. Eucalyptus Wind, 1993, wood and fabric,60"x20"x20"
2. Tree Shaman, wood, stone, leather,1995, 65"x22"x22"

emil**lukas**

learning a **language**

*layering surfaces
stratifying surfaces
into something more
than two-dimensional
but less than
three-dimensional,
a fractal dimension*

I communicate in my own language.

Instead of making paintings or sculptures, I feel closer to the act of using characters. These characters are my own self-made language, system, alphabet and personal vocabulary. As life and work go forward, characters are invented, abandoned, merged and rein-vented. This language is pushed around by my environment, the seasons, and, most importantly, by the life of the studio itself.

Everything emerges and merges in the studio. For me, the studio is not just a place to work and me, the person who works in it. The studio is a living system and I merely try to nurture and control how it functions.

My role is to continue, observe and group ongoing experiments that are being played out: buckets of larvae hatching from eggs that have been collected from decaying animals; glass boxes with pupating larvae hatching into flies; waste pits collecting and hardening the refuse from the preceding months and days; leaves cast in plaster that are draining chlorophyll and turning into bright colors; walnuts with husks rotting into black-brown ink; paint cans and sticks for my kids to compete with a Tom Waits song; the delicate pattern of a butterfly wing picked from the grill of the Dodge, mingling with a thread system on cotton paper; failed paintings entering a recycling process where they will be cut to size, reordered and become the foundation for a new work.

My intimate agenda is about arranging all this new work as it spills from one category into the next. Taking these categories into their new systems and placing numbers on the sides of each piece of thirty two sections and saying to myself: "Well, what do we have here? What is this? It looks like thirty two sections about growth". I move on to the next experiment, delicately slamming it into the by-products produced by the previous "Thirty two Sections About Growth", and so on. I want my images to flow along and show, not their geological condition, but their continual restarting and recombining.

As more people become familiar with my work, a few simple questions are often asked. "What is your work about?" and "How did you get started with your work?" To the first question, I like the answer "Life, death and a few things in between". The answer to the second question is a bit more involved. I usually say that I didn't start, I continued. I continue this work because it is work and I need to work. What that means is that there is a crucial balance with the dysfunctional. Since I am dyslexic, this balance is a life-long necessity that has and will persist. It persists in compensation for skills that have failed and through this failure arises the need to make art.

emil lukas

process: experimenting
practice: linking, stacking,
recombining

Emil is a sculptor whose work is in a
constant state of change. Every part is
linked in some way to a preceding piece,
and contains, sometimes in fragmentary
form, traces of what has gone before. One
never sees more than a portion of a
stacked sculpture at one time. A viewer is
asked to participate in the creative process,
to physically move the parts, and create his
own meaning or arrangement. "Thirty two
Sections About Growth" and "Ground Pack"
are interlocking stacks of small panels that,
when piled up, resemble a stack of books.
A viewer must physically move the panels
in order to see the individual images or
pages. As the forms unfold, each interface
makes visible a connection between two
pieces: a transfer of stains through
permeable materials, a dovetailing of relief
elements. At one point, a fish head serves
as a channel to connect three panels.
Painting and sculpture meld together
synergistically. The secret, alchemical
metamorphosis of the hidden and unex-
pected invite a viewer to take part in
constructing and deconstructing text and
meaning. Emil lives with his wife and three
children in a small Pennsylvania town.

plates
1. Thirty Two Sections About Growth,
1995, plaster, wood, mixed media,
36"x13"x12"
2. Ground Pack, 1993, plaster, hydrocal,
paper, plastic with thread, 15"x13"x11"
3. Three Printings About Lines that Run,
1995, mixed media on canvas, 33"x48"x3"

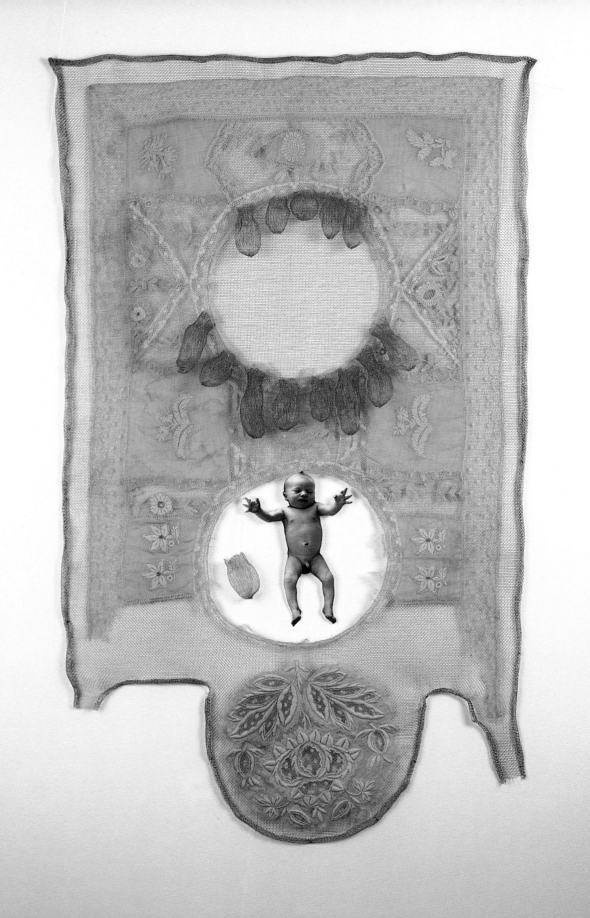

rebecca didomenico

cracking open the shell

What comes out of a hermetically sealed vessel?
A reservoir locked in the truth of the body?
One riddle after the next
delivered from a state of grace?
I listen with upsidedown eyes,
leave seams open, dismantle assumptions
while objects in the universe collide
and separate at will.
A single seed breaks through the illusion,
extracting the shadow from a source of luminosity.
I see all the way through myself and still,
a veil where the form is hiding.

Alchemy is the major source for my work.

It strikes me as a perfect metaphor for art and life, both personal and universal. One takes the raw material of life, the prima materia, and transforms it into gold; a work of art, or living an artful life. The process involves preparing the ingredients (laying out art supplies or setting up life conditions), distilling the ingredients (organizing or working with materials to bring out their essence), separating (adding and subtracting elements in order to reunite them), and finally cooking them (applying the necessary heat or energy for transformation). Alchemy is like a Zen koan, a riddle with no answers. I simply attempt to remain open enough to ask the right questions and embrace the mystery of life by trying magic combinations.

Alchemy depends on balance and faith; not necessarily religious faith, but a belief in process as a recipe for life. At my center, is the process of making things with my hands. Hands appear frequently in my work and are an essential tool. I thrive on the freedom to express, the suspension of judgment, the foolish yet compelling nature of the journey and the utter magic of transformation that is literally at my fingertips.

I am most fulfilled when art and life become one. I may repot a plant in the greenhouse and learn how to repot an art piece, allowing it to expand to its potential. Or I find myself at a boring dinner, and shift perspectives, looking at everything cinematically, filming everyone's shoes and the patterns they make moving across the floor. I feel an aliveness that cannot be pushed down. Sometimes, when I am overwhelmed with my various roles as wife, mother, artist, and community member, a breakthrough occurs. If I am very tired, I can't honor it with expression. This, too, is an aspect of manifesting my visions; the willingness to stay with the details when it becomes difficult or too revealing.

I am a scavenger at heart. I scavenge at garage sales and junk stores. When I find something that speaks to me, I bring it home and live with it for a while. It is like having a new friend or collaborator. Sometimes I go looking for a specific object, a certain sized glass box, a small rock to fit in a particular space. People leave things on my doorstep; things they have discarded or collected for me. Elements from other people's lives are inserted into my pieces and vice versa. Images and ideas are out there, floating around, making an impact on all kinds of people. All I have to do is be aware enough to know when to put my hand out there. If I become blocked, I take it as a sign to reflect; to collect materials, read, travel, take in performances such as dance, music and art openings. When my senses are alert, the flashes are non-stop.

My house, garden and studio environments are very important to me. I designed my house as a huge sculpture to live in. This, too, is part of my creative work. I poured my heart into every part of it. I mixed colored concrete pigment in a concrete truck, laid Japanese pebbles in the floor, constructed light fixtures from salvaged materials, collected cabinets from restaurant supply houses, church doors, railroad station ladders; I painted, sandblasted and cut all types of materials. Now, I live in that house and am getting down to the deeper work.

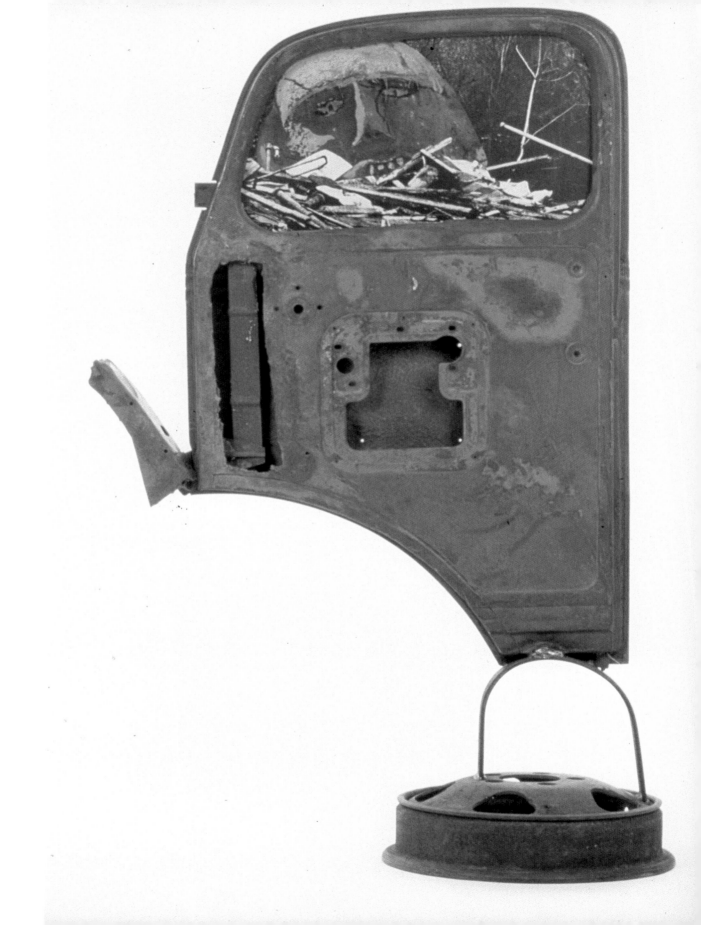

Part of my purpose in life is to inspire others to create, regardless of their doubts. In my experience, doubt is integral to the creative process. I throw out my inner critic at least long enough for what's inside to come out. Freedom to express without judgment is the way impossible things come into being. When I let in the critical voices, I observe them and take in relevant information. It is a trick to distinguish between the chorus of voices inside of me. I make lists of complaints and requests. Then, when I get stuck, I go out and do something on the list. I cannot possibly document everything, but I try to record key points. Sometimes my deep internal questioning is externalized with a person: a teacher, artist or friend. I record their feedback. In that way I can go back later and see if it makes sense. It is important, however, to never give up the power behind the true self.

I have to keep creating, even when everything seems terribly wrong and I lose the purpose or reason for creating. It is then that I wonder who I really am, without my artist identity or any other titles. My true purpose is to transmit life, with as much integrity as possible. As D.H. Lawrence wrote: "When we fail to transmit life, life fails to flow through us." The key word here is transmit. The experience I seek is that of allowing the divine mystery to pass through me, to move from one person to the next. I work at penetrating this mystery, dissolving the tension between being a participant in living and removing myself in order to observe and record. The final illusion is that these are somehow separate issues, incompatible, even impossible to integrate. Perhaps, when the final layer is peeled back, all journeys are linked by a common spirit, that reveals an infinite garden of interrelated paths.

A musical series started when I found a piano in a mountain town. I saw a piece of charred wood on the street, turned it over and there was a piano. It had been in a fire and all that was left were the cast iron innards. I took it back to the studio and started to work on it, weaving threads between the strings and unraveling them, like Penelope's web. At the same time, I discovered synathesia, which is a crossing over of the senses, the sound of a color, the texture of a smell. I had inadvertantly stumbled across the key to my inner workings. This is exactly what I experience, a combined sensory reality. It is a diagram for recording life and art, not as conflicting agendas, but as a whole picture with everything moving in unison. I scoured music repair stores for more broken down instruments and came across a stack of piano keyboards. They became canvases for me, black and white maps of my journey. I made xerox images, cut them into narrow strips and used the keyboards to piece the images together. The figure became a part of the instrument and the instrument part of the figure. It was a huge breakthrough. I experienced synathesia on many levels and from that moment on this sensibility became part of my process.

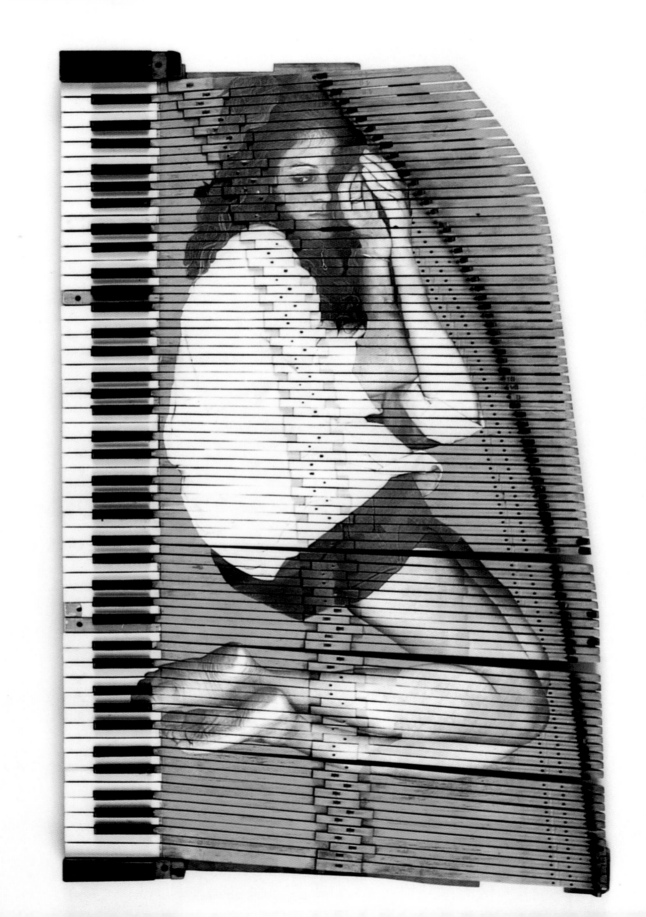

Serendipity is essential to my process. One day, I was rummaging around a used machinery shop and came across a small roll of metal tape, a very fine screen woven in a flat tube. I bought all they had. One day, I was reorganizing materials in my studio, which is what I do when I am stuck, and I came across this sensual material, that I had almost forgotten. Instinctively, I began reshaping it by inserting my thumb and pushing out. I made little sacks, one after the other and sewed them together. I laid them down on a piece of old lace and was struck by the delicacy and disparity of the materials: metal and cloth. The sacks were like anatomical parts, little wombs or amniotic vessels.

The lace held an historical feminine reference. I searched for a photograph I had taken of my son when he was only a few days old. I cut him out, attached a thread and hung the photograph from the lace. I had been working on some other pieces at the time, but nothing was coming together. Usually, the pieces that end up working for me come fairly effortlessly. I mean that putting the piece together was time consuming, but I did not struggle with the process.

There is an important preparation stage that involves simply being in the studio, working with materials, making visual and psychological connections. This part of the process is like using a primer on canvas. If I had not been prepared, the piece probably would not have happened! When I reach this stage, I have to keep going, no matter how tired I am. My concentration clicks in and, perhaps, a certain amount of exhaustion that is actually necessary to escape the confines or booby traps of the mind.

"The Truth of the Body" is about the birthing process, and also giving birth to a work of art, the labor involved in growing something inside and the violation to one's body to bring it into physical existence. I am constantly drawn to the precarious nature of life, like the tenuousness of the metaphoric little metal sacks hanging by a mere thread. Often I do not understand what I have created. I have to live with it and then slowly I can read a life from the piece.

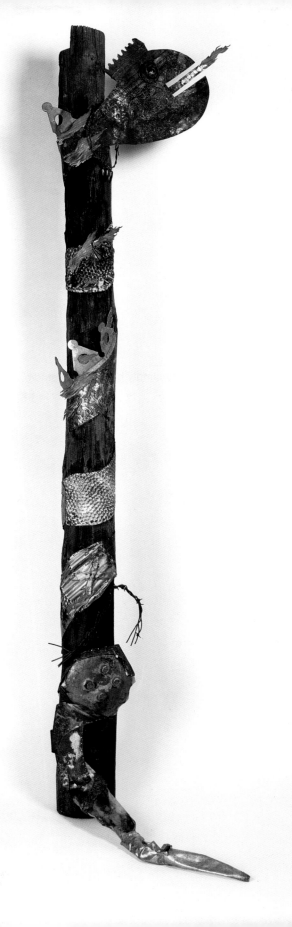

rebecca didomenico

process: reconciling aspects
** of the self**
practice: alchemy

Alchemical transformation and
continuing exploratory processes
are at the heart of Rebecca's
intimate engagement with creativ-
ity. Writing both prose and poetry,
painting, assemblage, photogra-
phy, dreamwork, architectural
design and building construction
are all varied aspects of this
unceasing and multifaceted quest.
Her capacity to witness and
consciously attend to the unfold-
ment of her life and art with
compelling clarity is her most
powerful creative tool. The
conscious experiencing of our-
selves, our lives and work is
known as witnessing. With
practice, we can all remember and
reveal more of ourselves.
Rebecca lives in Boulder, Colo-
rado, with her husband and son.

plates
1. Truth of the Body, 1995, lace,
wire mesh, photograph, screen,
32"x19"x1"
2. Primitive Man, 1987, car door,
handcolored photograph,
65"x41"x22"
3. Single Voice Fugue, 1985,
color xeox and piano keyboard
35"x50"x4"
4. Serpent Wand, 1995, wood, tin,
paint, 76"x20"x25"

Those of us who are not artists
are trying to close the book.
The artist opens it,
showing that there are still more pages possible...
One does not have to be a painter or sculptor
to be an artist.
One can work in any medium.
One simply has to find the gain
in the work itself, not outside it...
robert henri

All of us deal with the self. Who am I? How can I find my own vision? It is only by risking, questioning and exploring that we discover who we truely are: our authentic, original, creative selves.

...and this our life
when was it truely ours?
and when are we truely
whatever we are?
octavio paz

This adventure is about us,
about the deep self,
meaning not that which is new,
but that which is fully
and originally ourselves.
stephen nachmanovitch

the multi-
layeredsynthesis

agendaafterword

Creativity is becoming a way of life, an emerging life style. Creative expression is no longer the exclusive domain of a few accomplished individuals but is accessible to everyone.

Creativity requires long term practice and sustained stretches of dedicated behavior, but it can bring many blessings. It requires time, but it can open us to the timeless moment. It requires effort, but can become effortless. Practice is hard work, at least in the beginning. The initial discomfort usually turns into an endless source of delight. The process itself takes us to ever higher levels of creative functioning. It is an enormous commitment.

Sustained creative practice is required to solidify both personal focus and technical skills. Lynn Heitler describes the years spent developing her current printmaking techniques, a tedious process, but one that now brings her endless pleasure. Rebecca DiDomenico is developing the capacity to witness or consciously experience herself and her work. For Lynn and Rebecca, daily life and creativity merge into uniquely personal practices. The most commonly utilized practices are meditation, journaling and repetitive physical exercise with a journal becoming the most essential tool. Journaling is an ongoing mirroring practice that reflects the process of life itself.

The workspace or studio is the seminal space, especially for an artist like Emil Lukas whose experimental work is specifically a studio process. Others juxtapose studio time with travel and adventure. They move outward into new environments for stimulation and return to the studio for introspection, meditative seclusion and solutions to the next project. Nancy Head, Allison Stewart, Peter Stark, and Ann Sperry exemplify this style by traveling. At the far end of the spectrum is Patrick Dougherty who is without studio and works only on location. However, all of them move inward and outward to sustain the delicate balance.

This process poses existential questions about birth and death, beginnings and endings, the continuing cosmic adventure. Artists face, on a daily basis, a perpetual gap between external visible data and the capacity to intuit, understand or translate what they sense and feel into a meaningful image or form. Dreams are sometimes a source of new information and creativity. Jeremy Taylor, Morley Clark and Rebecca Didomenico use dreams as a creative resource and, even while sleeping, work on personal and creative problem solving.

One of the purposes of this book is to assist in the communication between artist and viewer. It examines artists who are experimenting with and opening to a variety of newly discovered processes, energies and materials. It describes the struggle to find a way into and through the creative process by trying things out, discovering what works, and what is personally true. It requires integrity to follow this path. Creativity becomes clearer when we explore the relationship between product, process and practice, for it is in the space between them that the creative potential resides. This is the interspace, the gap between known and unknown, visible and invisible.

The intimate agenda graphically illustrates how an artist and an artwork coalesce, each evoking the essence of the other, until outer form exposes inner image. Art is the outer embodiment of inner images, the result of a dialogue that crystallizes within an artist, moving him or her into a space where something new is created. There is a mutuality of process, a reciprocal fulfillment of inner and outer.

A similar process occurred while designing, editing and assembling this book. We tried not to impose an outer form, to avoid premature closure and maintain an ongoing dialogue in order to discover what form the book wanted to take. The best part of fitting together the pieces for a project such as this one, a book totally open to process, is the constant surprise and excitement of seeing it unfold. It started out with a rough plan, but the book itself took over and decided where it wanted to go. It synthesizes the creative work of many into a layered composite that reflects a message of change and transformation, the message that is inherent in process. There were many surprises.

The book is designed to evoke a response that moves one into deeper levels of awareness by exposing the intimate and creative expressions of contributors who

suspend their privacy for the sake of communicating with a reader. They speak directly, connecting us to the intimate experiences of their lives, to feelings and intentions that lurk just below the surface. Creative intimacy is communicating on the deepest level with whoever sees, hears or reads an artwork. The diverse processes and practices set forth in this book are tailored to fit their originator's lifestyle, medium and work habits, but they provide a model for others to follow. Everyone speaks in a singular voice, but the aggregate of the group as a whole, posesses unity beneath the diversity. Practice and experience can place us in the right place to generate ideas, but at some point intuition takes over before a new artwork emerges. Sometimes an accident suggests a solution. Whatever the route, we must have a starting point.

Creativity is tuning into evolving patterns of energy that lie within and around us and expressing what we sense and see. As we learn to reflect these energies, we discover, often to our own surprise, that creativity is readily available. In nature this process is called evolution, but individuals become conduits through which these same trans-personal forces flow. Contributors speak about the potential of space and place, the transformative power of dreams and alchemy, the blurring of edges in spaces of transition, balancing outer action and inner experience, eliminating boundaries between visible and invisible, physical and metaphysical. They express humility and fallibility as they expose their inner agendas.

Over a lifetime, we develop individual styles that bridge the gap between controlled, orderly expression and that which is accidental, energetic and free. Every painting we paint, every sculpture we sculpt and every book we write reflects our personal agenda back to us with clarity and precision. We may edit, erase and redo but the singular qualities and peculiarities of our personal style are indelibly exposed. Creativity exposes the inner self as we discover subtle traces of reality that are ours alone. The form that a creative work takes must be discovered by each individual for themself.

Creativity is a link to the invisible world of essential qualities and perceptions that gives our existence a sense of meaning and purpose. We need not become famous artists or writers. The point is simply that we remain unique, open and self-defined. We all are explorers on the creative path.

barbara seidel

agenda directory

carol anthony painter and printmaker
respecting silence
Leaping Powder Road, box 73 AT, Rte 9, Santa Fe, NM, 87505
505 820 2251

linda aroyan artist and writer
redesigning a life
6021 Shelter Bay, Mill Valley, CA, 94941
415 388 3611

morley clark painter
looking between the lines
Sonoma, CA

rebecca didomenico photo assemblagist
cracking open the shell
3547 4th Street, Boulder, CO, 80304
303 440 4432

angela danadjieva architect and urban planner
envisioning the future
1100 Mar West, Suite A, Tiburon, CA, 94920
415 435 2000

patrick dougherty site specific sculptor
fusing man and nature
9007 Dodsons Crossroads, Chapel Hill, NC, 27516
919 967 6533

michael emmons furniture maker and sculptor
and speaking with love
Parrington Road, Big Sur, CA, 93920
408 667 2133

nancy head painter and hand papermaker
retrieving the soul
1960 Loop Road, Fortuna, CA, 95540
707 725 3993

lynn heitler printmaker and painter
abstracting a place
565 Circle Drive, Denver, CO, 80206
303 333 6636

lewis knauss fiber artist and teacher
recording the landscape
Box 173, 12 West Willow Grove, Philadelphia, PA, 19118
215 248 0784

cristina lazar graphic designer and painter
16 Calypso Shores
Novato, CA 94949
415 883 1131

emil lukas painter-sculptor
learning a language
302 Main Sreet, Stockerton, PA, 18083
610 746 0914

barbara seidel mixed media and publisher
paring down to essence
Box 548, Aspen, CO, 81612
970 925 3421

ann sperry sculptor
engaging form and space
115 Central Park West, New York, NY, 10023
212 595 3020

peter stark outdoor writer
playing at the edge
1042 Monroe Street, Missoula, MT, 59802
406 721 5156

allison stewart painter and sculptor
exploring sacred places
1301 Marengo Sreet, New Orleans, LA, 70115
504 897 3623

jeremy taylor minister, teacher and author
dreaming as an art form
10 Pleasant Lane, San Rafael, CA, 94901
415 454 2793

augusta thomas musical composer
painting with sound
4 Starathallan Park, Rochester, NY, 14607
716 473 5279

agenda**resources**

Many opportunities are available for moving inside the creative process by attending workshops that offer assistance in developing creative processes and practices.

The Anderson Ranch Center for the Arts, box 5508, Snowmass, CO, 81615, 970 923 3181
This art facility conducts more than fifty process oriented summer workshops in fields that include photography, painting, sculpture, woodworking and ceramics. Many of the artists participating in this book have, at one time or another, been part of their teaching staff. The center's location, high in the Rocky Mountains, adds a stimulating edge to the creative process.

The Association for the Study of Dreams, box 1600, Vienna, VA, 22185, 703 242 0062
This is a major clearing house for the study of dreams and dream group facilitators.

Eurythmy, 285 Hungry Hollow Road, Chestnut Ridge, NY, 10977, 914 352 5020
This school describes eurythmy as speech and music made visible. What we hear is not usually visible, but every sound has the quality of gesture, to which we are more attuned than we realize. Various programs are offered including an intensive artistic year for people from all walks of life. It provides an opportunity to learn how to express intimate, spontaneous gestures of beingness.

Esalen Institute, Highway 1, Big Sur, CA, 93920, 408 667 3000
Esalen is best known for its exploration of unrealized human capacities, a blend of East-West philosophies and experiential workshops. An increasing number of process workshops include painting, photography, ceramics and writing and are basically about demystifying the creative process. Esalen also offers dream workshops with Jeremy Taylor and others.

Frederick Franck, Zen of Seeing Retreats, Covered Bridge Road, Warwick, NY, 10090
The two main elements of these retreats are seeing and silence. There are not even any personal introductions. Instead of trying to be creative or original or make art, the goal is simply to trust what the eyes see and deepen the simple act of seeing through drawing.

Psychic Visioning, 91 Franklin Street, New York, NY, 10013, 212 925 5777
Psychic vision happens when an artist looks within, explores the inner self and gives it form. Nancy Azara, a well known sculptor, offers classes, both individual and group, that use artmaking and meditation as their foundation.